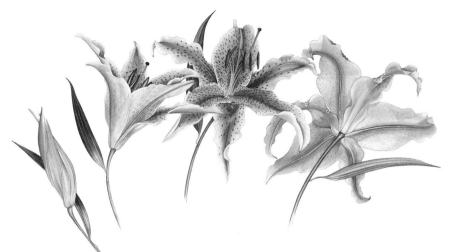

WATERCOLOUR
FLOWER
PORTRAITS

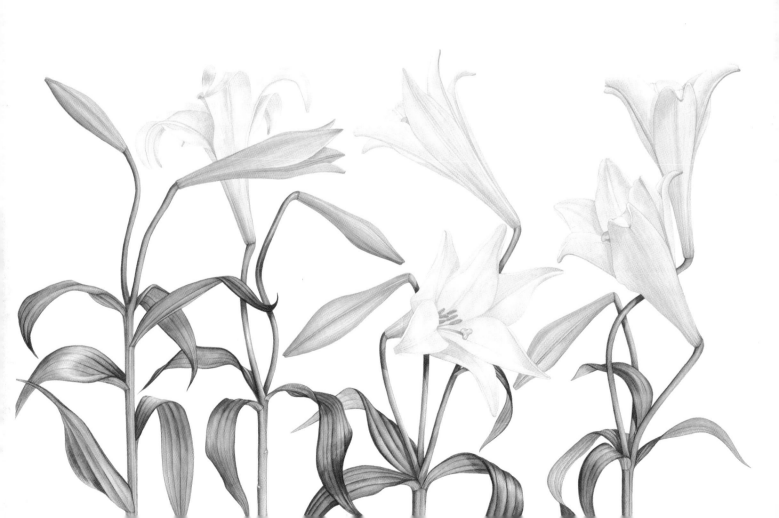

Dedication

I dedicate this book to my
wonderful parents, who gave me
my skills; to my husband and two
sons for all their support; and to
my whole family for all their love
and encouragement.

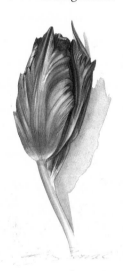

WATERCOLOUR FLOWER PORTRAITS

BILLY SHOWELL

First published in Great Britain 2006

Search Press Limited
Wellwood, North Farm Road,
Tunbridge Wells, Kent TN2 3DR

Text copyright © Billy Showell 2006

Photographs by Steve Crispe, Search Press Studios and
Storm Studios. Billy Showell's photograph (inside back flap) by
Walton Creative Limited.

Photographs and design copyright © Search Press Ltd. 2006

ISBN 1 84448 066 6

The Publishers and author can accept no responsibility for any
consequences arising from the information, advice or instructions
given in this publication.

Suppliers

If you have difficulty in obtaining any of the materials and equipment
mentioned in this book, then please visit the Search Press website for
details of suppliers: www.searchpress.com

Alternatively, you can visit the author's website:

www.billyshowell.co.uk

for a current list of stockists, including firms who operate a mail-
order service, or you can write to Winsor and Newton requesting a
list of distributors:

Winsor & Newton, UK Marketing,
Whitefriars Avenue, Harrow, Middlesex HA3 5RH

Publishers' note

All the step-by-step photographs in this book feature the
author, Billy Showell, demonstrating how to paint flower
portraits. No models have been used.

There is reference to sable hair and other animal hair brushes in
this book. It is the publishers' custom to recommend synthetic
materials as substitutes for animal products wherever possible.
There is now a large number of brushes available made from
artificial fibres and they are satisfactory substitutes for those
made from natural fibres.

Manufactured by Classicscan Pte Ltd, Singapore

Printed in Malaysia by Times Offset (M) Sdn Bhd

*I would like to thank Search Press for
publishing my book, especially Roz Dace for
pursuing me and eventually persuading me to
write it. I would also like to thank my editor,
Katie Chester, who has made it fun and less
scary – and thank you to Roz, Katie and
Steve Crispe, who took the
step-by-step photographs, for the friendly and
enjoyable painting sessions.*

*I am extremely grateful to my students who
have been wonderfully helpful with their
botanical knowledge, in which I am lacking,
and their enthusiasm. To my friends, many
many thanks for all their support, especially
those who have looked after my two sons at
the drop of a hat during this hectic year.*

*Finally, thank you to my fabulous family, all
of them, for giving me the confidence to
follow my own path.*

Front cover
Red Amaryllis
50 x 60cm (20 x 24in)

Back cover
Echinacea *(right)*
25 x 55cm (10 x 22in)
Gladioli Spray *(left)*
60 x 80cm (24 x 32in)

Page 1
Stargazer Opening *(top)*
80 x 60cm (32 x 24in)
Longiflorum Lilies *(bottom)*
80 x 60cm (32 x 24in)

Page 3
Nerine
60 x 80cm (24 x 32in)

Page 5
Strelitzia
60 x 80cm (24 x 32in)

Contents

Introduction

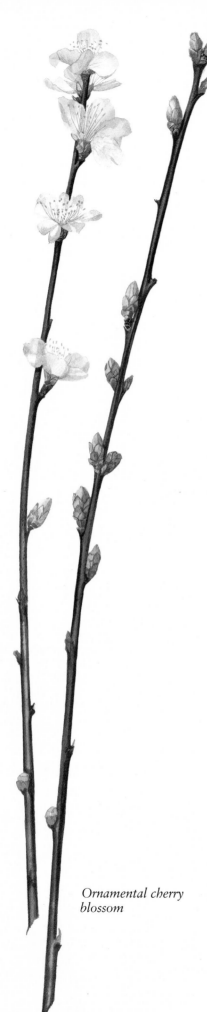

I have always loved drawing and painting. My earliest memories are of sitting in a corner of my grandparents' living room and drawing whatever came into my head, or asking the perpetual question, 'what shall I draw?'. Although I eventually studied fashion design, if I am totally honest with myself I was only ever really interested in the image on paper and the execution of it, and although I could design and make clothes, it was the drawing and illustration of the design I really loved.

Once married and expecting my first child I made the decision to change my career to painting, and with the support of my husband I began to paint. The first subject I chose was a lily from the garden. Though not the most successful painting I have ever done, it marked the beginning of a passion which now directs my life.

The flowers I paint come from many different sources. Friends and neighbours often offer me plants from their gardens, and I am a regular customer at the florist's and garden centre. Those I eventually paint are the ones whose shape, colour and intrinsic beauty inspire me, though the final form of a painting is dictated by the composition. I always carry a notebook about with me, and when I see an image that excites me I note it down or make a sketch and use it later in the studio. I always work from the flower itself rather than from a photograph; photographs alter the shade and colour intensity of the subject and are therefore a poor reference from which to work.

I am not a botanist, and although I have tried to apply the correct botanical terms wherever necessary, this is first and foremost a book on painting and so I have kept the use of scientific terminology to a minimum.

Painting accurate portraits of flowers takes practice – my best advice is to paint or draw every day, even if it is for only ten minutes. Each sketch or painting will increase your confidence as well as your abilities. Do not throw any of your studies away – look back over them in a few months' time and you will be amazed by how your painting skills have improved.

If you love the flower you choose to paint, you are more likely to feel inspired and produce a successful painting. Take time to study the flower before you start painting, and make sketches to familiarise yourself with its anatomy.

Watercolour is a challenging medium, but your enthusiasm and confidence will grow once you have achieved a couple of successful washes, or completed a corner of a painting that was simple to execute yet magically realistic. When starting out in watercolour painting, I advise students to buy a small amount of the best materials – like a lot of pursuits in life, the better the materials the better the job. Students' watercolours, though cheaper, do not behave in the same way as artists' watercolours, and in my opinion they do not make realistic colours and tend to look dull. Poor quality paper may actually put you off painting and cheap brushes can be frustrating!

Starting out, I would buy one good sable brush, one good piece of high quality paper and three small tubes of artists' watercolour in the primary colours. Practise with these and use up all the paper before investing in another sheet from a different manufacturer. Eventually you will find the paper that suits you, and you will be ready to start painting flower portraits.

Ornamental cherry blossom

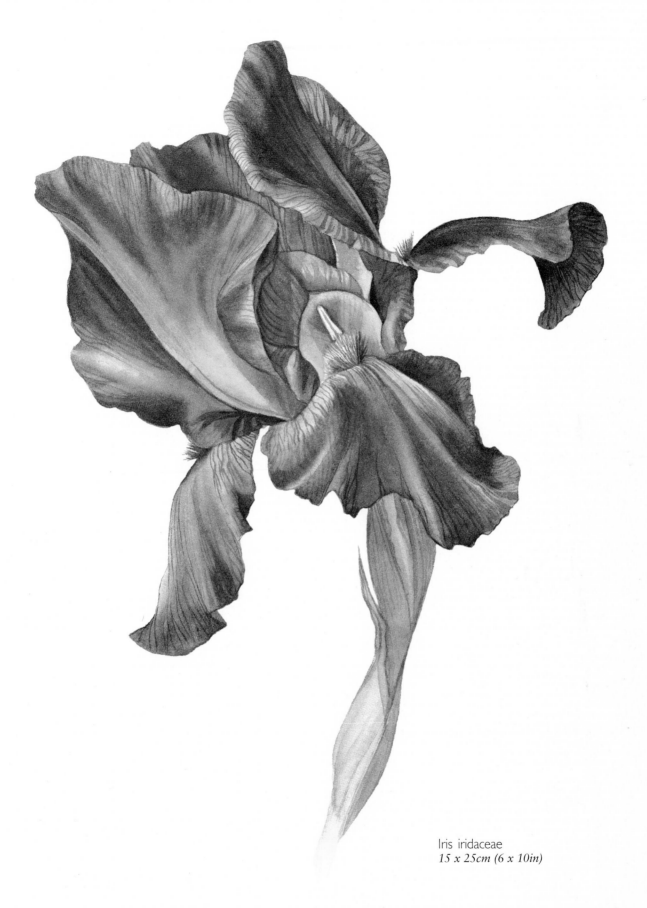

Iris iridaceae
15 x 25cm (6 x 10in)

I have no difficulty deciding what flower to paint. On seeing the right flower, I am filled with delight. I want that flower; I am in love with that flower. I have to paint it; I have to capture its beauty; I have to do it justice. This desire is what drives my painting; as a landscape painter is driven to capture a stunning view, or a portrait artist is inspired by a beautiful face.

What you need

Palette

I use a plastic food container for storing my tubes of paint and the lid makes a fantastic palette. I used the lid initially because I was being economical, but now I am quite attached to it as the puddles of paint spread out wonderfully.

Many colours look the same when dry, so it is good practice to always lay them out in the same order so that you can find them easily. The arrangement of colours in my own palette is shown on page 18.

Pencils

I use a good quality, sharp, HB pencil, though you can also use a fine, rotary pencil. Always work with a sharp pencil or your drawing will appear clumsy and you will not be able to draw in sufficient detail.

Paper

In my experience, the quality of the paper can have a huge effect on the results of your painting. When buying paper, my advice is to buy one sheet at a time. Keep a note in your diary or sketchbook of the make and weight of the paper, and then give it marks out of ten for performance. This way you will find the right paper for your style of painting.

In the majority of my paintings I use a slightly off-white paper, 100 per cent cotton, hot pressed at 600gsm (300lb) in weight. A good weight of paper to use when starting out would be 300gsm (140lb). Use the side of the paper on which the watermark is clearly readable. I have found that on this side of the paper the process of laying wet-into-wet glazes is far more predictable and therefore more successful. It is important to mention, however, that with many papers, especially hot pressed, both sides of the paper can be used.

Brushes

I recommend using a round sable brush. Most brushes have an adequate point and good handling qualities, similar to brush A below. This is a No. 6 brush, which is suitable for most types of flower painting. I use a No. 4, a No. 6 and a No. 12 mixed-fibre brush (above, left) if I need to cover a large area.

The type of brush that I personally use (brush B below) has a superb point that keeps its shape and is capable of painting very fine detail such as hairs. It also holds a large amount of paint so it is ideal for laying washes, and you can paint for some time before having to reload the brush.

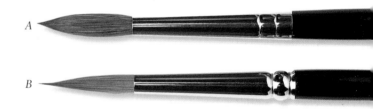

A

B

Eraser

I use a rubber pencil eraser, which you can cut into a point for accurate erasing. Many of my students use a putty rubber, which is possibly gentler on the paper.

Scalpel knife

A scalpel knife is useful for when I am unable to find my pencil sharpener, and I also use it for scraping out highlights at the end of a painting (see page 30).

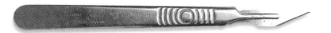

Masking fluid

I use masking fluid rarely, but when I do use it I apply it from a fine applicator bottle, or using an old paintbrush. Do not use your best brush as it may get damaged. Rub washing-up liquid into the hairs before dipping the brush into the fluid, and after use wash the brush out in clean water.

Magnifying glass

I keep a magnifying glass handy for those times when I really need to study the details of a flower.

Water pot

I use a large pot for water, filled to the top. This allows me to paint for a longer period without having to change the water.

Kitchen towel

To get rid of excess water from my paintbrush, I dab it on a roll of kitchen towel. Cotton cloth can also be used. I use plain white towel, as the ink from a pattern may come out on your painting if you use it to mop up a water spill. Do not use toilet paper as it disintegrates too easily.

Notebook

I always carry a small notebook or sketchbook with me. I jot down notes from exhibitions or sketch objects or images I see around me. Any ideas on composition are recorded for use back in my studio. I also keep a record of colours and details of plants I observe 'in the field'. For this purpose I would also take out with me a small pad of hot-pressed paper and a travelling painting kit.

Paints

Always use artists' watercolours, even if you are a beginner or student. Cheap paints result in poor colour mixing and permanency. You will want your paint to spread and flow beautifully and not fade, and this can only be achieved with good quality pigments. Artists' watercolours will also last a long time. I now use tubes rather than blocks; I found myself scrubbing the blocks trying to lift enough colour on to my brush, and damaging my brush in the process.

Drawing

When I begin drawing a flower I like to work straight on to the watercolour paper. Usually, I would already have drawn out the design for the finished painting in my notebook, so it is just a matter of finding the right angle for the flower and drawing it lightly in the correct position.

Use a sharp, HB pencil or a fine, rotary pencil and have a pencil eraser or putty rubber to hand. Try not to make too many mistakes, and do not erase them until you have finished your drawing to prevent the paper from being damaged by excessive rubbing out. Do not press too hard with your pencil or you will score the paper. This will also make the pencil lines harder to remove.

Only draw the outline or silhouette of the flower; the paint will provide pattern and detail. Too many pencil lines will be difficult to rub out and will confuse you when laying the washes.

Before you start to draw, take time to study the flower. If it is a simple flower, count the petals and see how the flower heads are joined to the stem. This can be an enlightening process. On close inspection you will find that flowers are far more intricately detailed than you originally thought, and are even more beautiful than you first perceived them to be.

Once you understand the structure of a flower you will be better able to draw it, and to choose how best to compose your painting (see page 58). Look at the flower from all different angles, and choose the one that tells the best story; the one that best shows off the flower's shape and how it curves and grows.

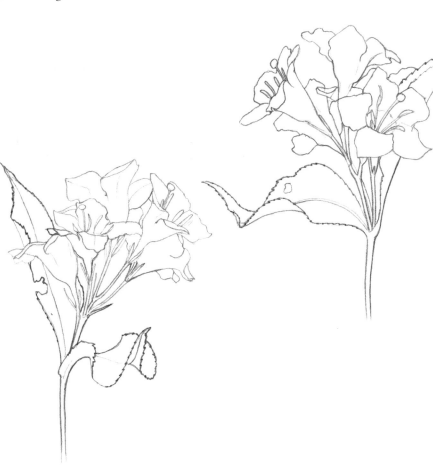

In the study on the left I have shown two views of the same albelia sprig. The far left-hand drawing has too many flowers facing away, leaving too many flower stems in the middle of the study. The bottom leaf is foreshortened, and although interesting, the drawing does not portray the plant in the most aesthetic way.

The right-hand drawing shows the same flowers from the side, leaning away from and facing the viewer, and the leaf is at a far more graceful angle.

Pattern

To produce an accurate painting, it is essential to be able to see, and to reproduce, pattern. Pattern occurs everywhere in nature. The circular arrangement of petals around the centre of a daisy; the way the stamens grow around a central pistil; the blend of colours on a tulip petal – all these form a pattern which you will want to reproduce in your painting.

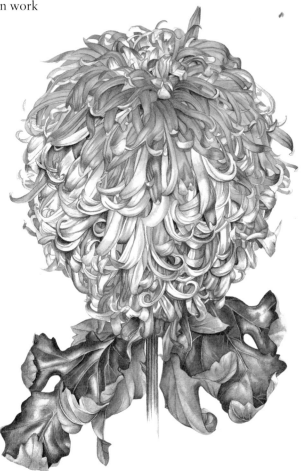

The bracts travel around the cardoon head shown right in a spiral pattern. Use diagonal lines to help with the spacing of them. (The flowers are contained within the bracts and ascend as the plant matures.)

If a flower has a particularly complex structure, like the chrysanthemum below, it may be difficult to spot any sort of pattern in the arrangement of its petals, stamens and so on. It is essential that you find an easily recognisable point within the flower that will help you locate your position as you paint. I find it simpler to start by drawing the silhouette of the flower then work outwards from a point in the centre.

The painting above took eight long days to paint. The leaves had to be painted first as they wilted quickly.

Drawing flowers

Being able to see the basic shape of a flower will help you to draw it. In the following studies I have drawn in the basic geometric shapes of the flowers. Normally these would not form part of my drawing – this is purely an exercise to show you the overall shape of each flower. If you keep this shape in mind while you are sketching, it will help you achieve more realistic dimensions in your painting.

This zantedeschia (calla lily) has one large petal (spathe) that wraps around to create a cone shape. The lip of the spathe extends out of the cone shape. When drawing flowers like this, pay careful attention to the curving edges. When you come to paint, the way the light falls on these curves helps to define the interior space. As the flower matures, the lip of the spathe curls further back.

This iris takes a triangular form. It has three large petals (which are actually sepals that resemble petals) with a bright yellow flash. On top of these are three pairs of petals and three single ones, which create a second triangular pattern superimposed on the first.

This gerbera, in common with other daisy-like flowers, is circular in shape, therefore when it is viewed from the side it creates an ellipse. Flowers like this are easier to paint if you draw the negative spaces between the petals (see page 17 for a discussion of negative space).

12

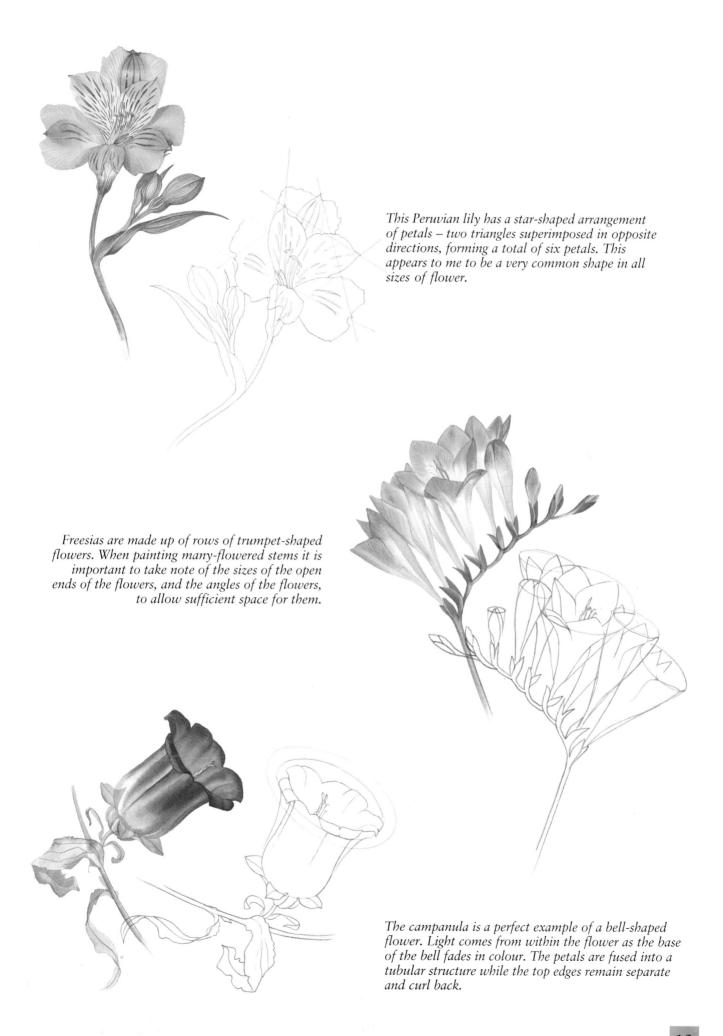

This Peruvian lily has a star-shaped arrangement of petals – two triangles superimposed in opposite directions, forming a total of six petals. This appears to me to be a very common shape in all sizes of flower.

Freesias are made up of rows of trumpet-shaped flowers. When painting many-flowered stems it is important to take note of the sizes of the open ends of the flowers, and the angles of the flowers, to allow sufficient space for them.

The campanula is a perfect example of a bell-shaped flower. Light comes from within the flower as the base of the bell fades in colour. The petals are fused into a tubular structure while the top edges remain separate and curl back.

Drawing leaves

Drawing leaves is an essential part of producing successful flower paintings. Leaves are just as important as the flowers, even if they are not the focus; they frame and complement the flower.

When setting out to draw the leaves, notice the arrangement and how they branch from the stem. Avoid, if you can, foreshortening a leaf so that it cuts the stem in half.

In this arrangement the tip of the central leaf is pointing straight down into the centre of the stem. When painted, the point will be lost.

In the arrangement on the right, each leaf has a pleasing form. You can see the undersides of the leaves, how they curve, and how they join the stem.

There are many variations on the way leaves are arranged along a stem. Take time to study the plant you are painting; it will affect how you decide to angle the plant on the paper.

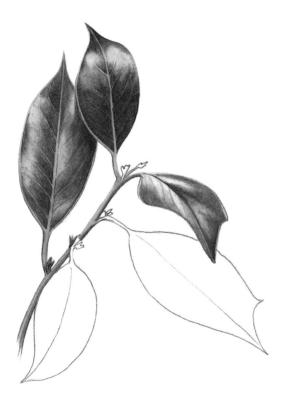

Here the leaves are arranged alternately, with a small leaf bud at each leaf axil.

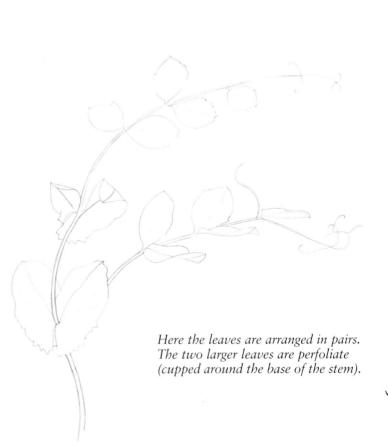

Here the leaves are arranged in pairs. The two larger leaves are perfoliate (cupped around the base of the stem).

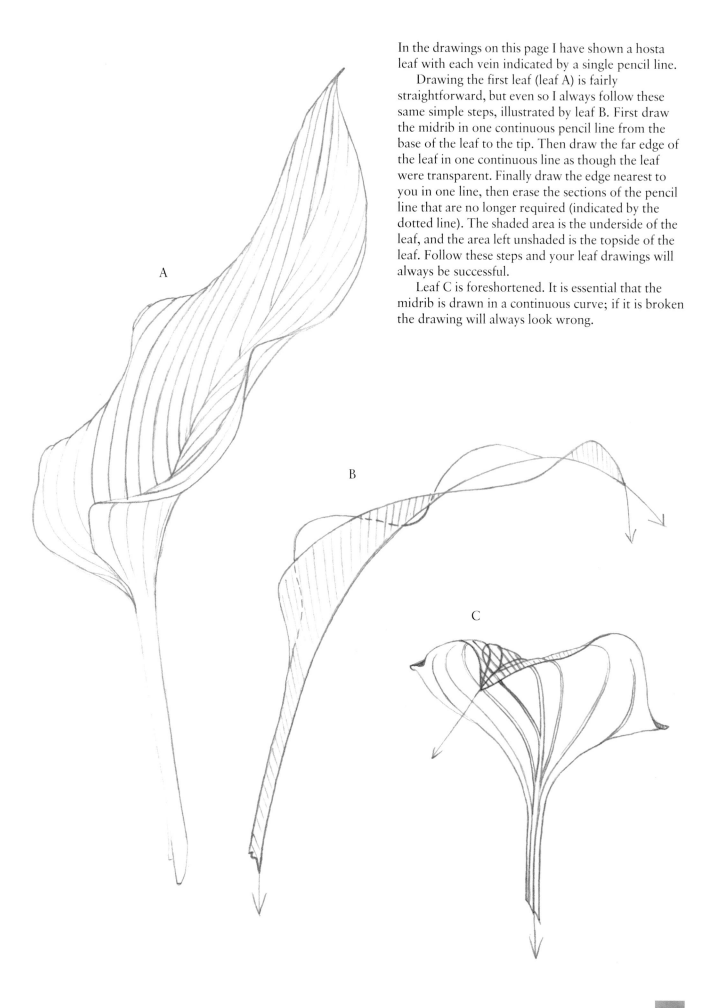

In the drawings on this page I have shown a hosta leaf with each vein indicated by a single pencil line.

Drawing the first leaf (leaf A) is fairly straightforward, but even so I always follow these same simple steps, illustrated by leaf B. First draw the midrib in one continuous pencil line from the base of the leaf to the tip. Then draw the far edge of the leaf in one continuous line as though the leaf were transparent. Finally draw the edge nearest to you in one line, then erase the sections of the pencil line that are no longer required (indicated by the dotted line). The shaded area is the underside of the leaf, and the area left unshaded is the topside of the leaf. Follow these steps and your leaf drawings will always be successful.

Leaf C is foreshortened. It is essential that the midrib is drawn in a continuous curve; if it is broken the drawing will always look wrong.

A

B

C

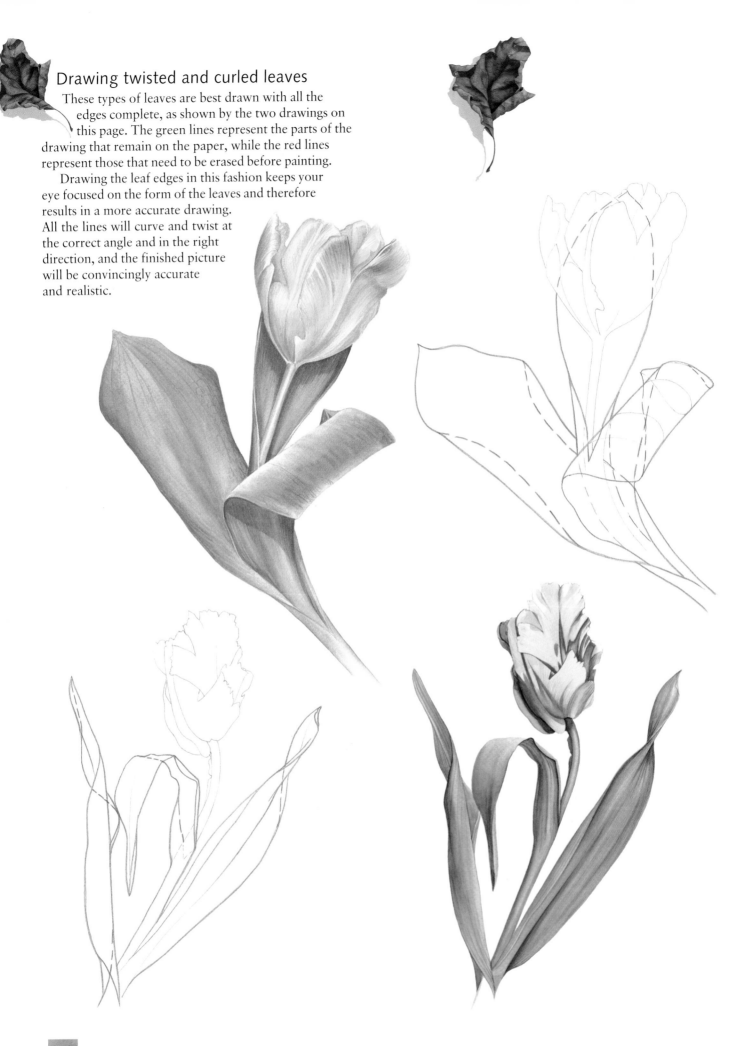

Drawing twisted and curled leaves

These types of leaves are best drawn with all the edges complete, as shown by the two drawings on this page. The green lines represent the parts of the drawing that remain on the paper, while the red lines represent those that need to be erased before painting.

Drawing the leaf edges in this fashion keeps your eye focused on the form of the leaves and therefore results in a more accurate drawing. All the lines will curve and twist at the correct angle and in the right direction, and the finished picture will be convincingly accurate and realistic.

16

Negative spaces

The drawings below are in boxes to demonstrate negative space. This concept is often referred to by artists but rarely explained properly. Negative space is the space between, in and around a shape or object. The spaces are easier to see in the diagrams on the right below, where the negative shapes have been shaded. If you draw the negative shapes, you can often produce a far more accurate drawing of the positive shape – the flower – than if you study the positive shape alone. This is because your brain does not recognise the negative shapes and makes no assumptions about what they should look like. You are forced to concentrate harder and to observe more clearly.

Positive shapes

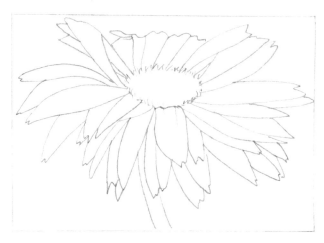

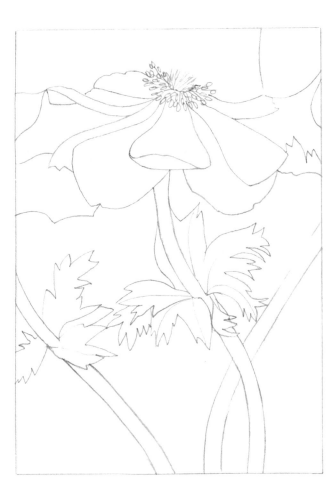

Negative shapes

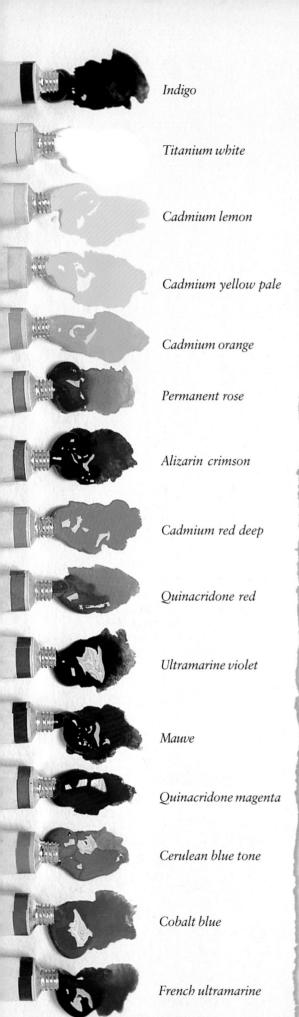

Indigo

Titanium white

Cadmium lemon

Cadmium yellow pale

Cadmium orange

Permanent rose

Alizarin crimson

Cadmium red deep

Quinacridone red

Ultramarine violet

Mauve

Quinacridone magenta

Cerulean blue tone

Cobalt blue

French ultramarine

Colour

When I first began watercolour painting I sought the advice of other artists and as a result of that developed a basic palette of colours which I have been building on and refining ever since.

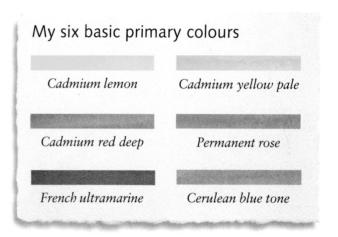

My six basic primary colours

Cadmium lemon	Cadmium yellow pale
Cadmium red deep	Permanent rose
French ultramarine	Cerulean blue tone

I am always trying out new colours and adding them to my palette. There are numerous guides on the market to choosing and mixing colours, but I think the best advice is to keep it simple and experiment as much as possible – the more you practise mixing colour, the more confident you will be when you start to paint flowers.

The colours that are currently in my palette are simply those with which I have experimented and achieved the best results. Laying out the colours on your palette may seem unimportant, but it is essential to know where each colour is. I group all the blues on one side, all the reds on the other side and the yellows along the top. The other hues are placed along the bottom, leaving plenty of space in the middle for mixing.

Space for mixing

Mixing colours

Primary colours – red, yellow and blue – are hues that cannot be made by combining other colours. Secondary colours – orange, purple and green – are created by mixing two primaries together, and tertiary (earth) colours are made by mixing either all three primaries or a primary and a secondary. In theory, therefore, you should be able to mix any colour you need from the three primaries.

There seems to be no paint that is a true primary; each contains a little of another, for example cerulean blue tone is a cool blue containing some yellow, and French ultramarine is a warm blue that contains some red. It is therefore best to choose a range of primaries and secondaries from which to mix other colours. With the infinite range of mixes these will provide, there is usually no need for the earth colours.

Complementary colours are opposites, for example the opposite of the primary colour yellow is purple, created by mixing blue and red in equal amounts. In nature, you see complementary colours used to amazing effect. Think of a purple iris with a flash of yellow, or bright red berries against deep green leaves.

Mixing cadmium yellow pale with permanent rose creates a deep, rich orange-red.

Mixing cadmium lemon and cadmium red deep creates a light orange (a true secondary). I introduce cadmium orange to my range of colours for the addition of a bright tangerine orange.

The tone of a colour is often overlooked when one is new to painting. Tone is the relative lightness or darkness of a colour, and it can be altered by adding water to the mix – the more water you add, the lighter the tone. Every colour and colour mix has a full range of tones. The flowers above show a range of tones of cadmium red deep, cadmium yellow and French ultramarine.

French ultramarine mixed with cadmium red deep creates a deep, dull purple. I introduced mauve, ultramarine violet and quinacridone magenta for a full range of purples.

Greens are created from yellow and blue. See page 25 for a fuller description of mixing greens.

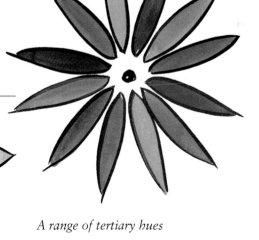

A range of tertiary hues

19

Mixing colours for flowers

There is a myriad of colours to be mixed when painting flowers. Even if you group them into hues such as pinks or blues, you are unlikely to find two flowers that require exactly the same blend.

In these studies I have described the various colour mixes I have used for each flower. Some have been blended on to wet paper, whereas others have been laid over each other, each layer being allowed to dry thoroughly before another glaze is applied.

Always practise mixing the colours first, then try them out on a piece of scrap paper before applying them to your painting. Remember to allow them to dry as watercolours fade to up to fifty per cent paler than when they are wet.

To avoid laying too many washes and overworking your picture, try to mix a colour that when dry is as close to the real flower's colour as possible.

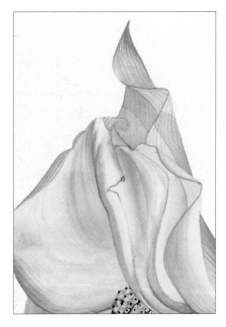

To create this lemon calla lily I used cadmium yellow pale and cadmium lemon overlaid with a light wash of mid-tone (French ultramarine, cadmium yellow pale and cadmium red deep; see page 34).

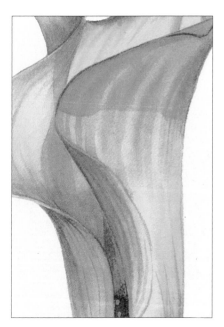

For this zantedeschia 'Aztec Gold', I used cadmium yellow pale with cadmium red deep laid into it while the wash was still wet, overlaid with pale washes of light green (cadmium yellow pale and cerulean blue tone).

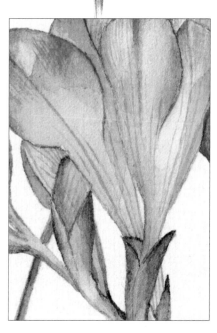

The colours of these freesias were created using cadmium yellow pale mixed with a touch of cadmium red deep, with either alizarin crimson or permanent rose laid into the glaze while it was still wet.

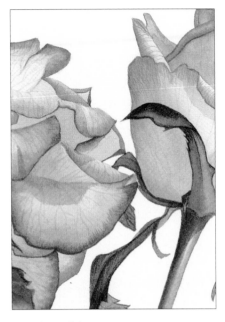

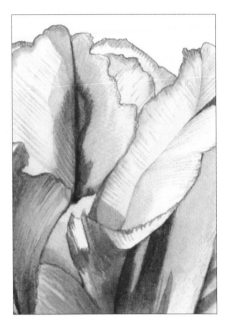

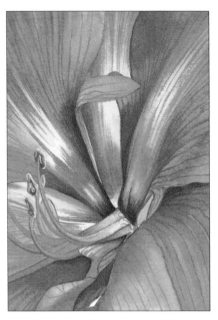

For these delicate Cezanne roses I mixed permanent rose with a small amount of cadmium yellow pale. The pale part of the petal is a light wash of mid-green (French ultramarine, cerulean blue tone and cadmium lemon) mixed with a pale wash of mid-tone (French ultramarine, cadmium yellow pale and cadmium red deep; see page 34).

Permanent rose mixed with alizarin crimson was used to create this variegated tulip; for the darker sections a little French ultramarine was added to the mix.

I painted this amaryllis using a mix of permanent rose and quinacridone red (a good strong mix of these two colours gives a deep, rich pink).

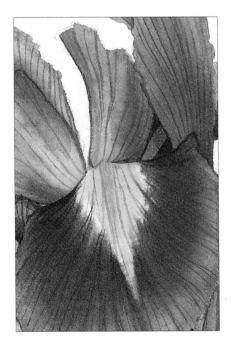

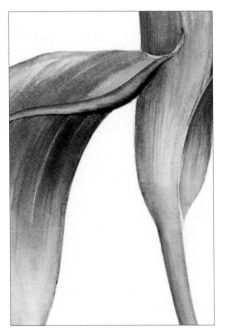

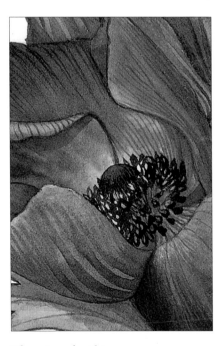

The stunning purple of the iris was created using ultramarine violet and cobalt blue laid into a water glaze, and the highlights lifted out.

Quinacridone magenta mixed with permanent rose was used for this zantedeschia 'Dusty Pink'. For the deep colour at the top of the spathe, French ultramarine was added. At its base a small amount cadmium red deep was mixed with the magenta and permanent rose.

The mixes for this anemone are ultramarine violet and alizarin crimson with lighter washes of mauve and cobalt blue. The deep colour of the centre is mauve and indigo with a wash of permanent rose and mauve behind.

21

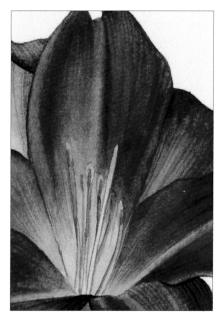

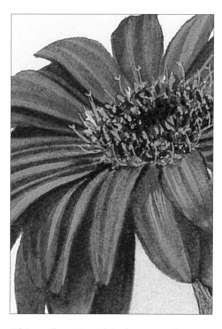

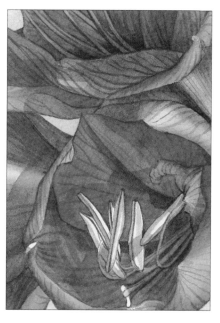

The colour of this hemerocallis was created by blending cadmium red deep and alizarin crimson on to a water glaze. The crimson was darkened by adding French ultramarine.

This gerbera is a fabulous postbox red. I created it by mixing cadmium red deep with quinacridone red.

I used cadmium red deep mixed with permanent rose to create the crisp red of this amaryllis. For the interior shades I added a little mauve.

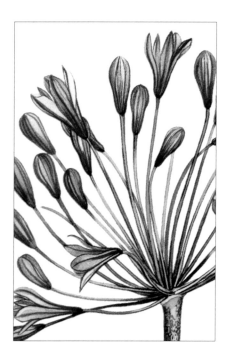

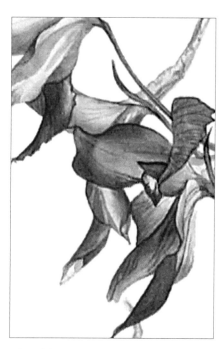

I mixed cobalt blue with mauve for this agapanthus. French ultramarine was added to the mix towards the base of each flower.

Cobalt blue blended with a small amount of mauve was used to create the delicate blue of the native bluebell.

This delphinium features in the project starting on page 116. French ultramarine was mixed with quinacridone magenta and laid with a wash of cobalt blue.

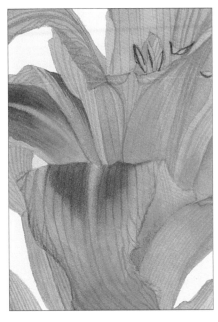

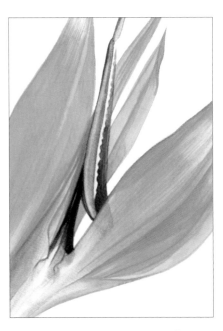

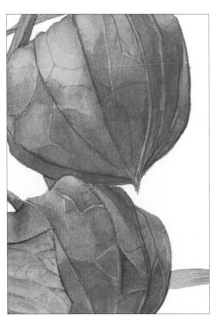

I used cadmium orange with alizarin crimson laid into it while the wash was still wet to paint this Hemerocallis fulva. For the underside of the petals I used a pale wash of cadmium orange and mid-tone (see page 34).

For this orange strelitzia I used a mix of cadmium orange and cadmium lemon on a wet glaze and lifted out the highlights.

The deep orange of these Chinese lanterns was created using a wash of permanent rose and cadmium yellow pale combined with another light glaze of cadmium orange.

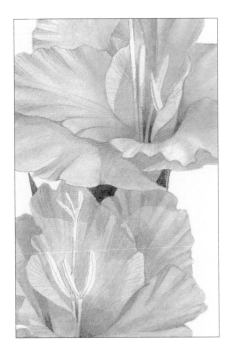

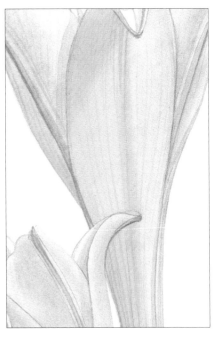

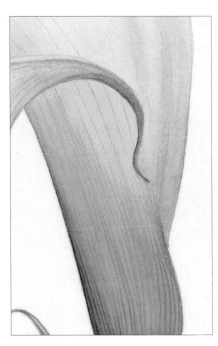

These gladioli 'Green Star' were a light fresh green fading to white. The green is cerulean blue tone mixed with cadmium lemon and a hint of French ultramarine.

As the longiflorum lily matures from bud to flower it retains a delicate blush of pale green. I mixed cerulean blue tone with cadmium yellow pale and a touch of cadmium red deep then watered it down to a pale glaze.

This arum lily has a deep, fresh green at the base of the spathe. I used a mix of French ultramarine with cadmium lemon and cadmium yellow pale.

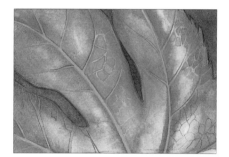

Orchid

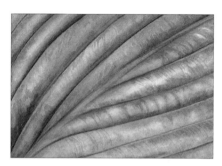

Fatsia japonica

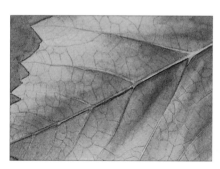

Hosta

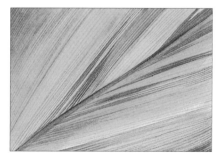

Vine

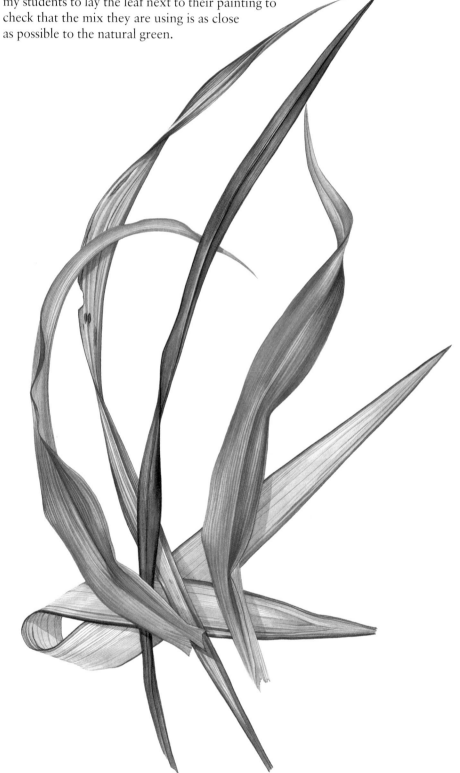

Mixing greens for leaves

Mixing accurate greens is the secret to painting beautiful leaves. A myriad of greens can be achieved with a very limited palette. I use only cadmium yellow pale, cadmium lemon, French ultramarine and cerulean blue tone. The beauty of the first three colours is that they lift off the paper fairly effortlessly, so it is easier to retain areas of light and reflection.

I have found that simply by adding a touch of cadmium red deep to any green makes it appear more natural. Interestingly, I have also noticed that we all see greens differently. With this in mind, I always tell my students to lay the leaf next to their painting to check that the mix they are using is as close as possible to the natural green.

Phormium

Below are examples of nine different greens, all with a base of cadmium yellow pale mixed with different combinations of French ultramarine, cerulean blue tone and cadmium red deep. Each of these greens has a full range of tones created simply by adding more water. I have repeated the exercise with cadmium lemon in leaves A to F.

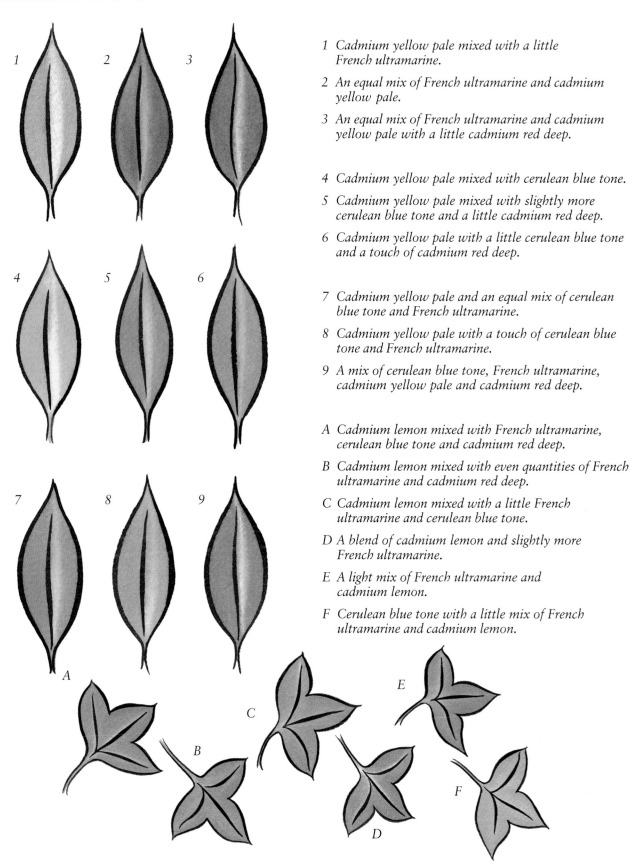

1 Cadmium yellow pale mixed with a little French ultramarine.

2 An equal mix of French ultramarine and cadmium yellow pale.

3 An equal mix of French ultramarine and cadmium yellow pale with a little cadmium red deep.

4 Cadmium yellow pale mixed with cerulean blue tone.

5 Cadmium yellow pale mixed with slightly more cerulean blue tone and a little cadmium red deep.

6 Cadmium yellow pale with a little cerulean blue tone and a touch of cadmium red deep.

7 Cadmium yellow pale and an equal mix of cerulean blue tone and French ultramarine.

8 Cadmium yellow pale with a touch of cerulean blue tone and French ultramarine.

9 A mix of cerulean blue tone, French ultramarine, cadmium yellow pale and cadmium red deep.

A Cadmium lemon mixed with French ultramarine, cerulean blue tone and cadmium red deep.

B Cadmium lemon mixed with even quantities of French ultramarine and cadmium red deep.

C Cadmium lemon mixed with a little French ultramarine and cerulean blue tone.

D A blend of cadmium lemon and slightly more French ultramarine.

E A light mix of French ultramarine and cadmium lemon.

F Cerulean blue tone with a little mix of French ultramarine and cadmium lemon.

Techniques

On these pages I have demonstrated some of the fundamental techniques that I use. Practise and master these techniques before you start your flower paintings, and you are far more likely to succeed.

The two golden rules are try not to rush, and always allow the colour to spread naturally. Constantly interfering with a wash while it is spreading, settling and drying will result in a messy finish. Practise dragging the paint using just two or three strokes and then leaving it to dry.

Wet-into-wet

This is the process by which I begin all my paintings. First I glaze over the paper with clear water and then I apply the paint on top of the glaze. This results in the paint spreading naturally across the paper rather than immediately soaking in to it, and it has a soft rather than a hard edge. Another advantage is that two or more colours can be applied at once, allowing you to blend them on the paper before they dry.

As there is a layer of water between paper and paint it is much easier to lift or mop up paint with a clean, damp brush. This technique is also used to create areas of light.

Dropping in colour

This technique involves loading your brush with paint so that it feeds easily off the brush on to the wet paper. It is used to create a soft, natural wash of colour.

1. Begin by carefully applying a clear water glaze. Keep the glaze within the shape you are painting – the paint will follow the path of the water, so a messy glaze will give a messy finish, and if you paint over the pencil lines they will be difficult to remove. Work on one petal or shape at a time, as the glaze dries quickly.

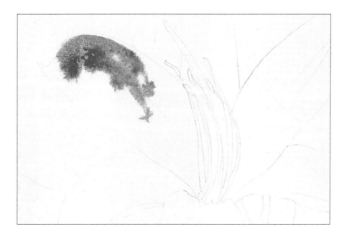

2. While the glaze is still wet, drop in the colour. The paint will feed readily off the brush on to the paper so avoid applying too much paint at this stage. With this petal, we want the colour to fade towards the centre of the flower, so add the colour at the tip.

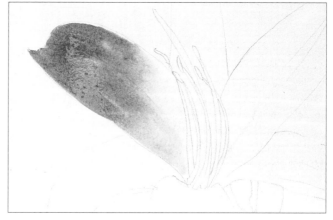

3. Spread the colour down the painting towards the base of the petal. Do this with a clean, damp brush. Sweep from the wet edge of the paint towards the flower centre.

26

Colour blending

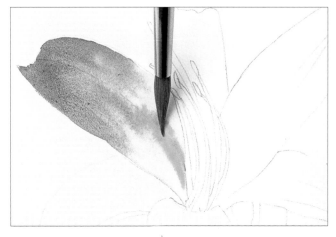

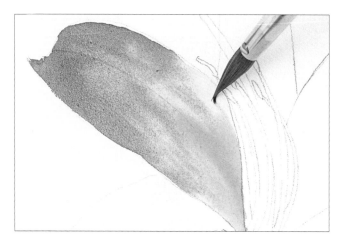

1. Drop in a second colour while the first colour is still wet. Use this colour sparingly with just the tip of the brush.

2. With a clean, virtually dry brush, sweep from the pale to the dark areas and blend the two colours together.

Lifting out colour

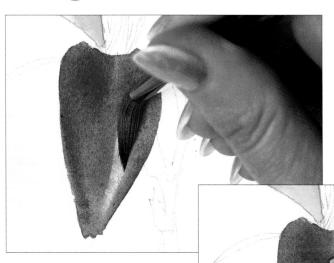

1. Having applied a wash of colour, while it is still wet use a clean, damp brush and carefully sweep up the unwanted paint to reveal highlights.

Tip

When you start to paint, lay a piece of clean paper or a sheet of acetate over your drawing to rest your hand on, otherwise you may smudge it.

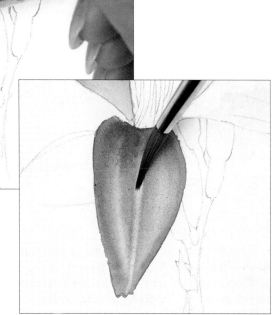

2. Work quickly if there are many highlights, as once the paint is dry it may prove impossible to lift off. Clean the brush between each sweep or you will reapply the colour you previously removed elsewhere.

3. When lifting paint off the paper, the brush must be drier than the painted paper so that it absorbs the paint.

Layering glazes

Layering glazes is the process whereby one wash of colour is laid over another. The first colour has to be dry or the second wash will upset or lift the first wash. Details such as veins and surface markings can be sandwiched between the layers of colour. This softens the detail and gives it a more natural appearance. I try not to put on more than three layers of colour, as the more layers you have, the more volatile the paint, and there is a danger of over-working the painting.

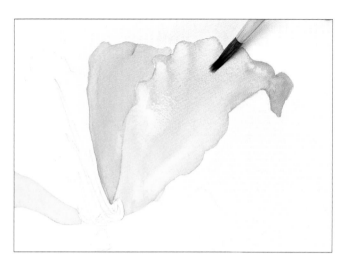

1. After the first wash of colour has completely dried, glaze over the top with clear water.

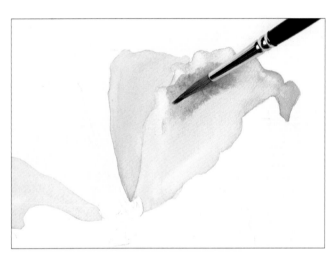

2. Apply a second colour and sweep it gently where needed. You can lift out some of this colour to reveal the colour beneath.

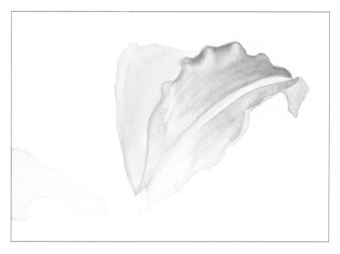

3. Lift out parts of the glaze in one direction, from base to tip. This accentuates how the petal curves and ripples. Allow this wash to dry.

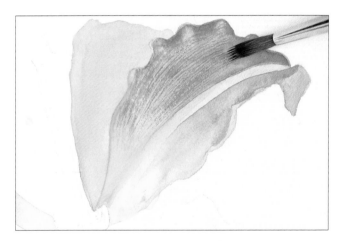

4. Apply detail using dry brushing and a deeper red (see the facing page).

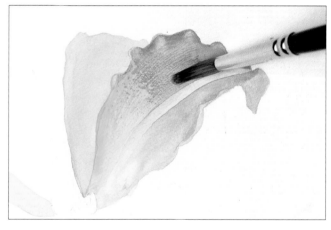

5. Apply a light colour over the totally dry work. The aim is to unify the tones and sandwich the details between layers of paint.

Dry brushing

This technique is used to create pattern and texture. It is done once the background colour has been applied and is completely dry. A steady hand is required for this technique, and it needs some practice to achieve convincing results. This technique works better with cold-pressed (Not) or rough paper, so you could practise with heavier paper and progress on to hot-pressed as you become more competent.

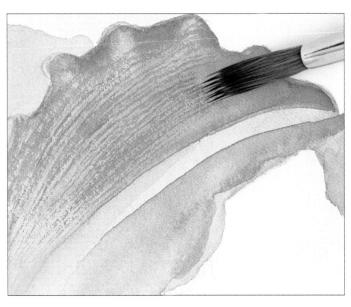

A close look at the daylily shows how the hairs of the brush are splayed out and a dry mix of red dragged across the paper to achieve a natural, broken pattern of veins.

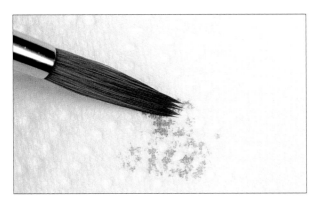

1. Make a fairly dark mix with just a little water. Load the brush and remove any excess paint by dabbing it on absorbent paper. The brush should be flattened to separate the hairs slightly.

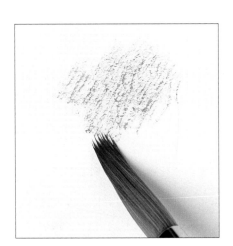

2. As you apply the paint to the paper, flatten the end of the brush. Only some of the paint goes on to the paper to create texture.

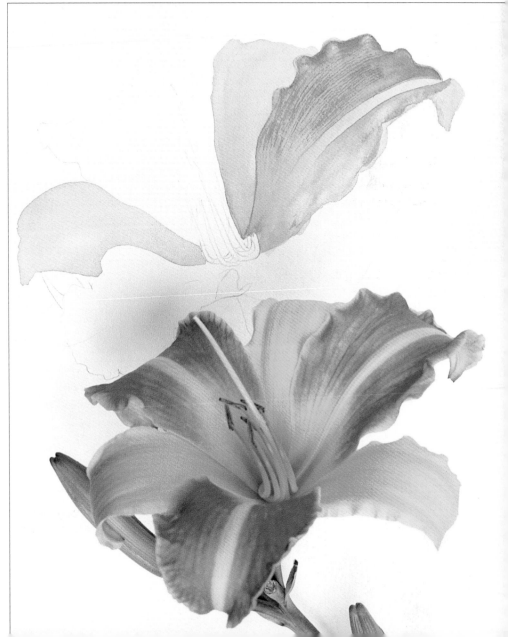

Hemerocallis 'Frans Hals'

Fine detail

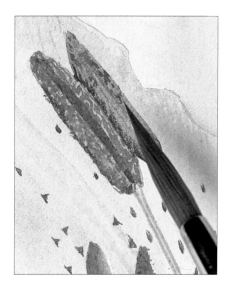

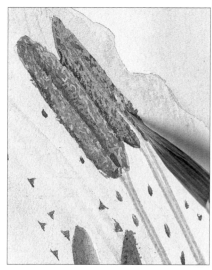

In the painting on the left, I used dry brushing for the pollen. First dot on the paint using a strong mix of red applied with the tip of the brush. The base colour of the stamens must be totally dry before doing this or the details will blur. Take your time on this, and use a magnifying glass if necessary. Once this layer of colour is completely dry, apply small dots of yellow over the top to highlight the red pollen.

Using the very tip of the brush, these raised markings on the surface of the petals were painted on to a dry background, and a small shadow applied to each one. Without the addition of these tiny shadows, the three-dimensional appearance of the markings would be lost.

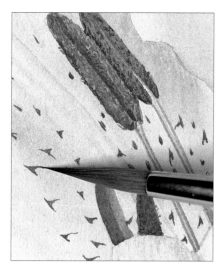

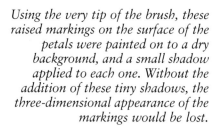

Scratching off

This technique is used to create small sharp highlights. As it involves scraping away the paint to reveal the paper underneath, some damage to the paper is inevitable. It should therefore only be done once the painting is finished.

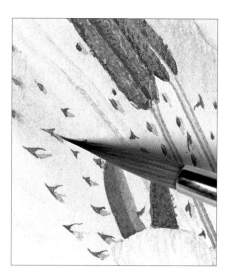

Gently scrape off the paint with the tip of a scalpel to create the highlight.

Applying masking fluid

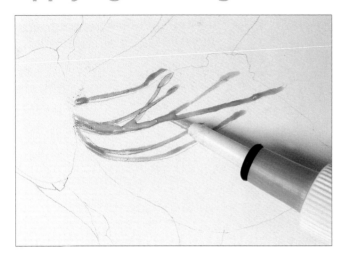

Masking fluid is useful if you wish to retain areas of white paper. When applied to dry paper it protects that part of the paper from all washes of colour. Only when the painting is completely dry can the masking fluid be removed.

I find it works well for fine details like stamens, fine stems or holes in leaves. I try not to use it for highlights as it leaves a very hard outline.

1. Apply the masking fluid to clean, dry paper. Leave it to dry completely (this takes about five to ten minutes) before applying paint.

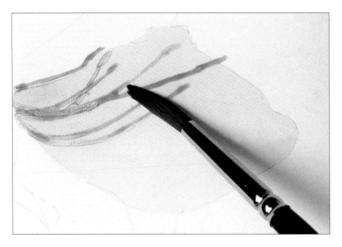

2. Lay the paint over the masking fluid. Take care not to drag the brush too hard or you may dislodge the masking fluid.

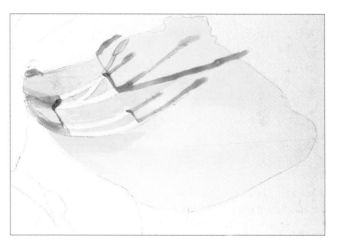

3. When the paint is completely dry, rub off the masking fluid using your finger tips (if the paint is even slightly wet, the paper may tear).

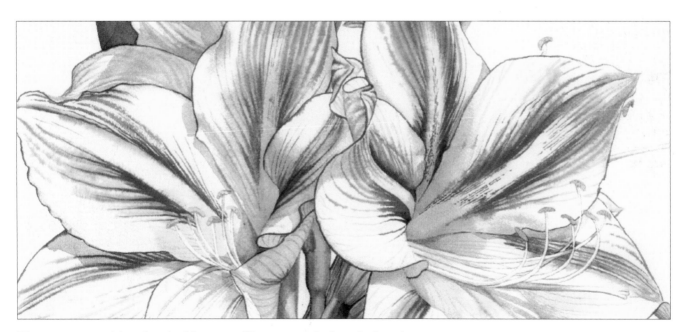

The stamens on this red and white amaryllis were masked out before the flowers were painted.

Strengthening colour

This study shows how you can intensify colour in stages.

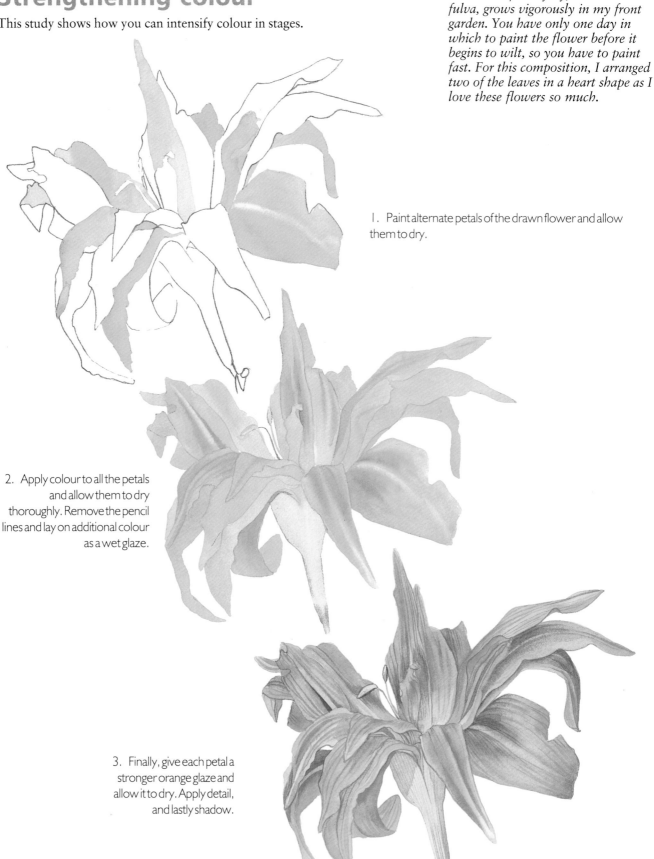

1. Paint alternate petals of the drawn flower and allow them to dry.

2. Apply colour to all the petals and allow them to dry thoroughly. Remove the pencil lines and lay on additional colour as a wet glaze.

3. Finally, give each petal a stronger orange glaze and allow it to dry. Apply detail, and lastly shadow.

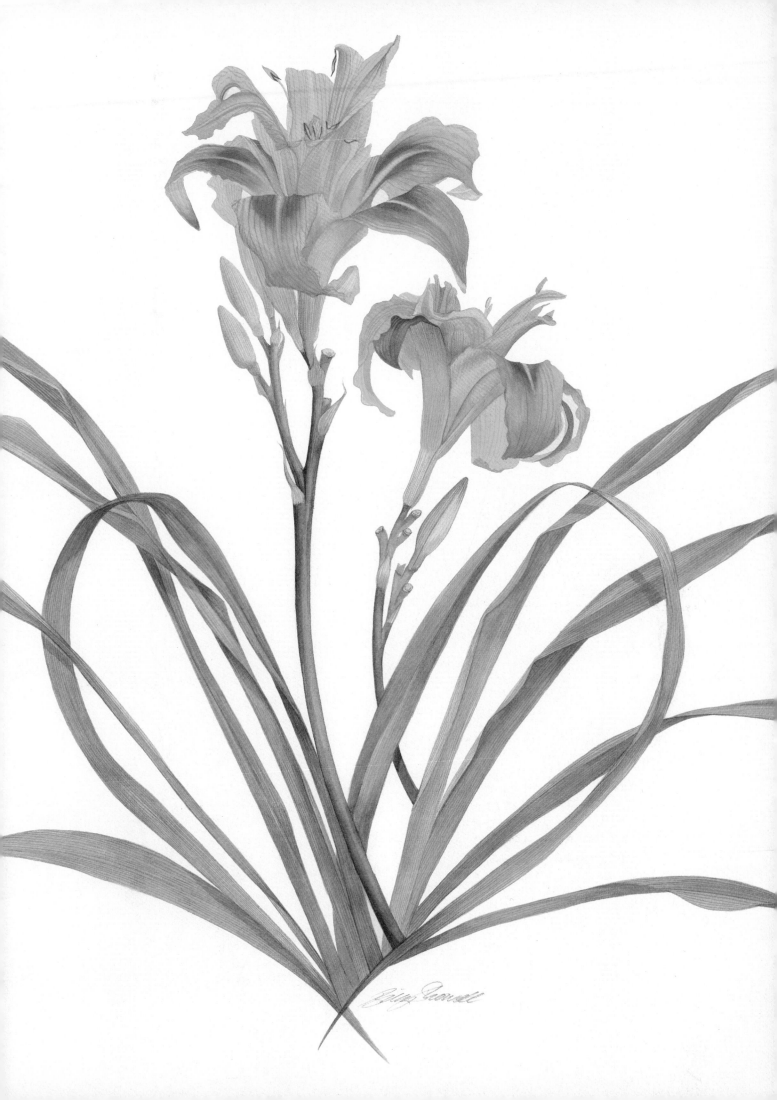

Light and shade

Shadows are not strictly acceptable in traditional botanical illustrations, but in my own paintings I include them wherever possible. They give depth to a painting in an instant, and in many cases they are a fundamental part of the composition.

Sunlight changes constantly throughout the day, so the shadows change as well. It is therefore essential to use a good, bright, artificial light source. This way the shapes of the shadows are constant and easier to paint. I use a 50watt halogen angle lamp.

The mid-tone mix

The basic mix I use for all my shadows is a mid-tone mix of two parts French ultramarine to one part cadmium red deep to one part cadmium yellow pale. The mixes shown here have progressively more water added to them as you move from left to right.

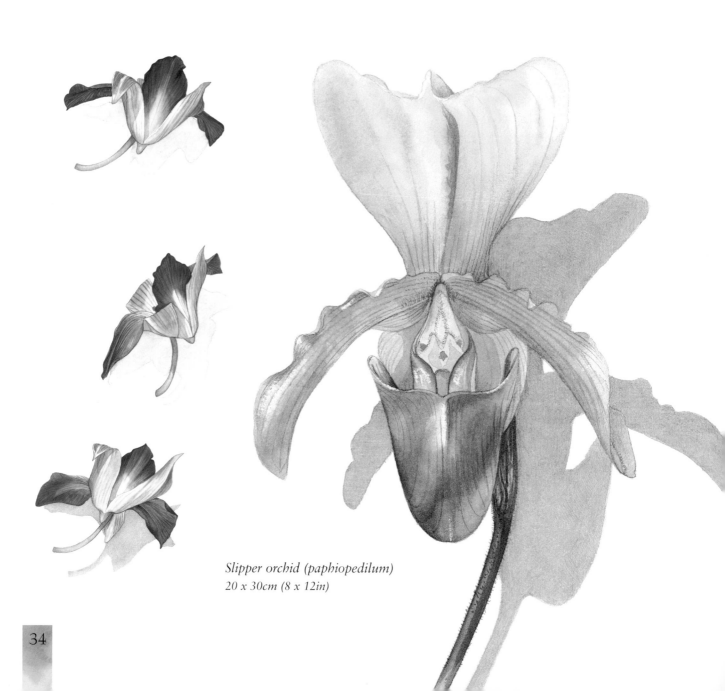

Slipper orchid (paphiopedilum)
20 x 30cm (8 x 12in)

34

Adding shadows

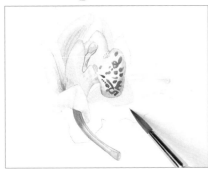

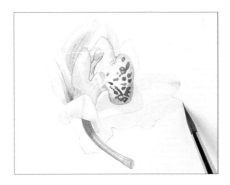

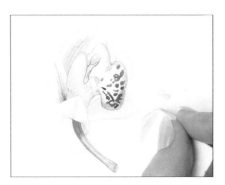

1. Begin by making a watery mid-tone mix consisting of two parts French ultramarine, one part cadmium red and one part cadmium yellow pale. Draw a light outline for the shadow, and apply an even glaze of clear water over the shaded areas.

2. Stir the mid-tone mix well in case the colours have settled out, and apply a wash of colour over the glaze. Lay the wash as flat and even as possible to avoid lines appearing as it dries. Do not go back over any of the painted areas before they are dry, otherwise the wash will become uneven and patchy.

3. Complete all the shadowed areas and allow the paint to dry thoroughly. Rub out all the pencil lines.

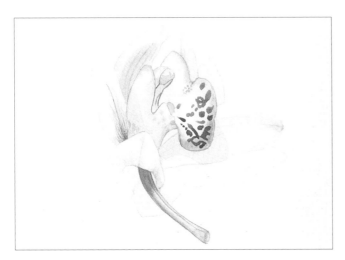

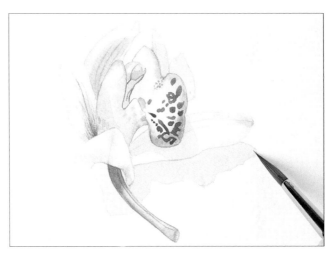

4. Apply a second clear glaze of water evenly over the shadow. Make sure that you match the shape of the shadow precisely.

5. Lay on the shadow mix, creating darker areas where needed. To achieve more depth of colour, repeat steps 4 and 5.

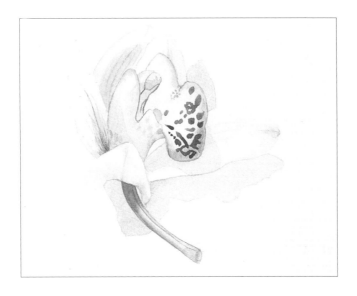

The completed painting. If you prefer your shadow to have a soft edge, apply the paint to wet paper. This method is less precise, but may be more suitable for your painting.

Creating areas of light ...

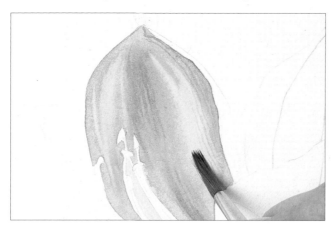

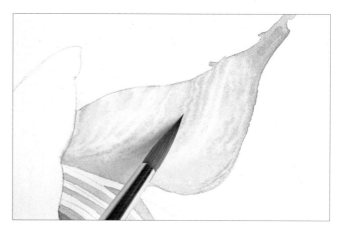

1. I rarely apply white paint to give the impression of light. It is dull compared with the paper and leaves the painting looking flat. Instead, lift out the paint on the parts of the flower where the light is hitting it to reveal the white paper underneath. This produces a softer, more lifelike, effect.

2. Finer areas of light can be lifted out with the point of a brush. Here, the brush is 'wiggled' slightly whilst lifting to produce texture.

... and shade

The depth of shadow applied to a flower depends on the intensity of light falling upon it. The shadow colour is the same mid-tone mix as described on page 34 but with some of the flower's main colour, or a touch of any colour that is reflected on to the flower, mixed in. I usually apply the shadows cast by light at the end of a painting, after applying tone and detail. They unify the layers and give depth to the painting. One exception to this is yellow flowers, to which I apply all the shadows in lilac before laying on the yellow tone.

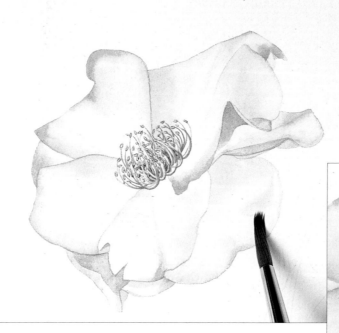

Apply shadows in watery layers, and soften the finished edges with a clean, damp brush.

Applying shadows to details, such as stamens and raised markings, instantly lifts the painting and produces a three-dimensional effect.

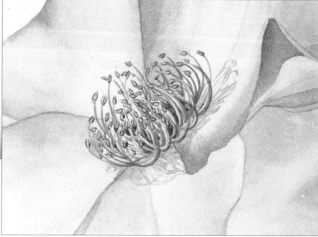

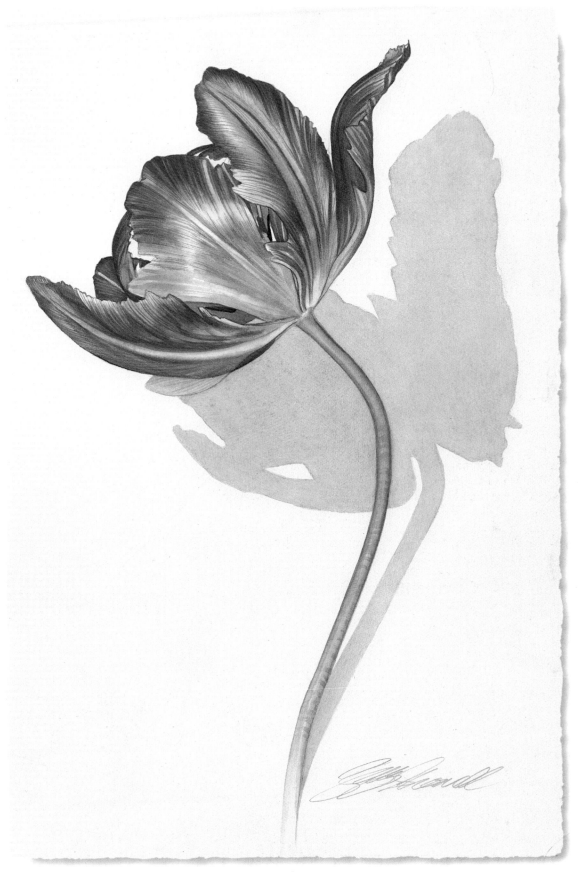

Lilac Parrot
20 x 30cm (8 x 12in)

*This is a painting of the only tulip to bloom in my garden. The petals caught the
light beautifully, and I painted it with a strong shadow to create more drama.*

White flowers

I love painting white flowers. Lilies are my favourite; each stage of their life cycle has its own unique characteristics which are a joy to paint – as buds they are simple and elegant, and when in full bloom delightful patterns are created by the areas of light and shadow.

The aim is to capture the white of the paper within a pattern of subtle shadows without the use of white paint. In some light the shadows can be very dark. These must be executed with care to avoid the painting becoming too heavy – in this case, less is more.

For some, the degree of subtlety required to paint white flowers on a white background may be disconcerting. But this is exactly what I love about these portraits. For me, white flowers portray calmness, tranquillity and purity. When I have completed a painting of white flowers I immediately want to start another picture.

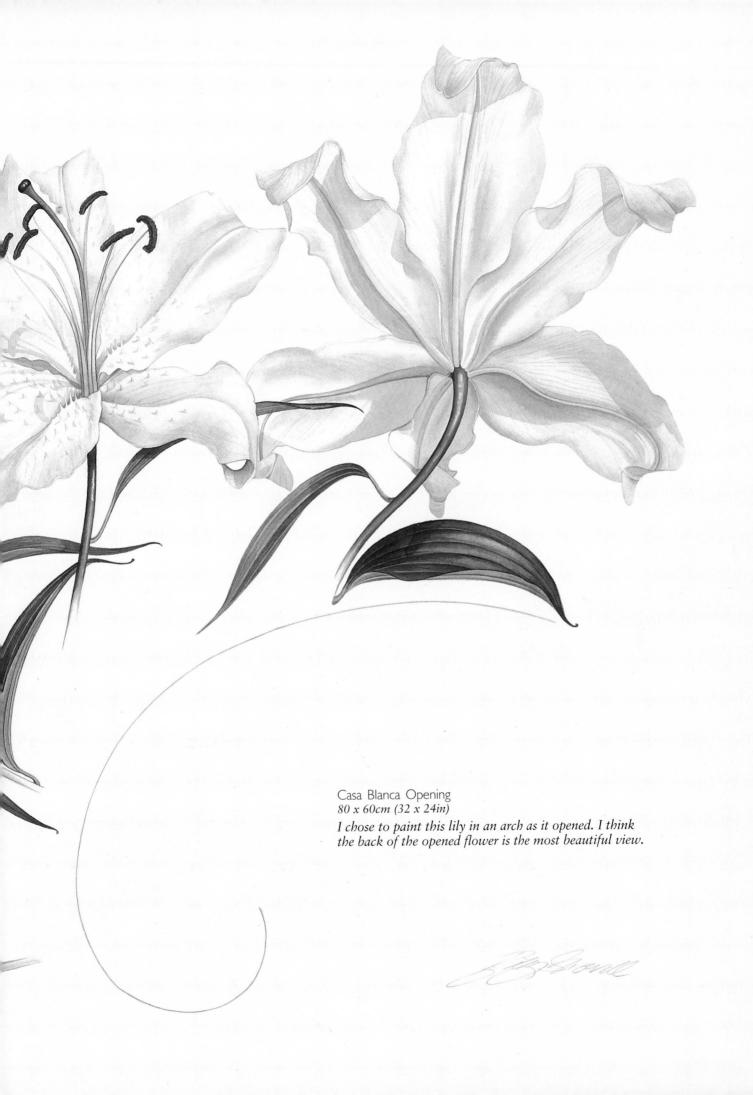

Casa Blanca Opening
80 x 60cm (32 x 24in)

*I chose to paint this lily in an arch as it opened. I think
the back of the opened flower is the most beautiful view.*

Mixing shadow tones

To paint white flowers I begin with a mix of three primary colours which I call the mid-tone. It is a blend of two parts French ultramarine to one part cadmium yellow pale and one part cadmium red. This is my starter puddle of paint. I then make several other puddles of paint with subtle changes to match the colours I can see in the flower.

I begin by capturing the most descriptive shadows first and then apply further glazes of the shadow mix to create deeper shadows.

The mixes shown below are the ones I created to paint the white lily at the bottom of the page. Each one can be made lighter by adding water.

1 *Mid-tone*

2 *Mid-tone plus permanent rose*

3 *Mid-tone plus cadmium yellow pale*

4 *Mid-tone plus cerulean blue tone and cadmium lemon*

5 *Mid-tone plus a little more French ultramarine*

To paint the white lily below I first drew the lily, then applied the main shadow mixes on to a glaze of clear water. While each shadow was still wet I lifted out the highlights, then put on gentle shades of pale yellow and pink before removing all the pencil lines. To finish, I created drama by strengthening some of the shadows.

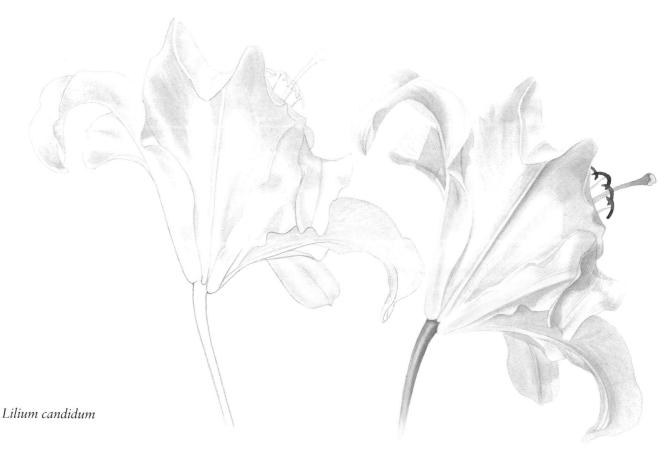

Lilium candidum

Painting a white arum lily

Here I have shown the stages in painting a white arum lily, *Zantedeschia aethiopica*. The lily is creamy white at the top of the spathe (the flower's single, curved petal) and a beautiful, bright, fresh green at the base.

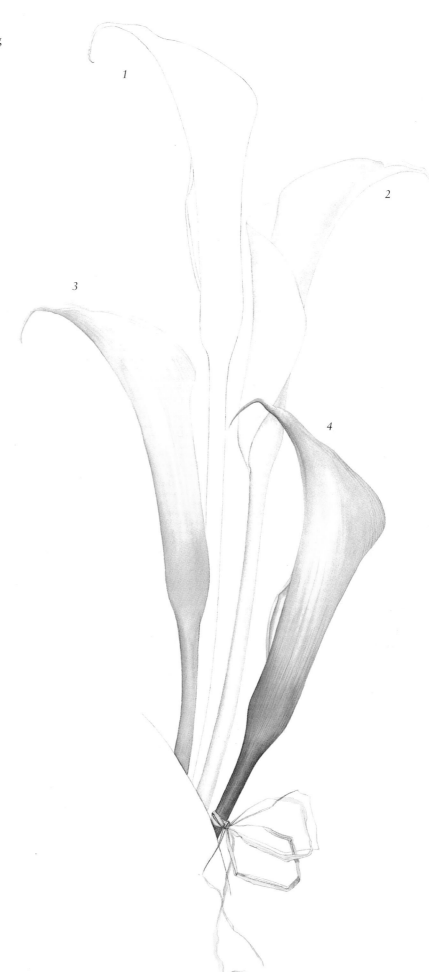

1. Draw a simple outline of the flower. Next, mix the mid-tone and one or two extra puddles with slightly more water.

2. Glaze the sections one at a time and lay on the shadows to create form.

3. Mix a light green of cerulean blue tone and cadmium yellow pale, and glaze over the first dry washes with water. Lay the light green on to the tip and the base, steering the colour gently up the spathe. Drop in more shadow mix while the flower is still wet. Lift out any veins or highlights and allow the painting to dry.

4. Finally, mix slightly stronger colours, adding French ultramarine to the green and darkening the mid-tone. Glaze the entire flower with water again and, using the tip of your brush, paint on the fine green veins and tiny grey veining towards the tip of the spathe.

41

Painting flowers in detail

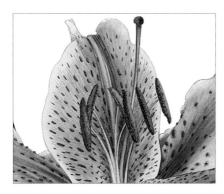

The exquisite diversity of flowers presents the artist with a challenging array of techniques to master. I think of it as mark-making; using the brush in a variety of ways to mimic nature. Preparation and observation are the key to success. Before you start to paint, study the plant's details carefully, if necessary using a magnifying glass. Familiarise yourself with its patterns and markings, trace the stamens back to their base and observe the texture of the stem, leaves and petals. Continue to observe the plant carefully while you are painting; always paint what you see, not what you think you *ought* to see.

Veining can be applied during the application of the layers of colour. Surface details, like stamens, anthers, thorns and hairs, should be added at the last stage of painting so that they are not disturbed by the washes.

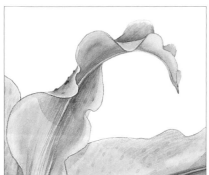

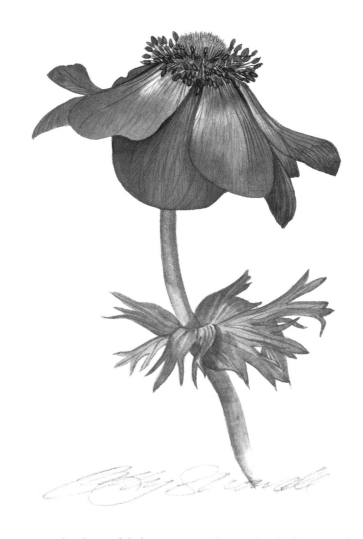

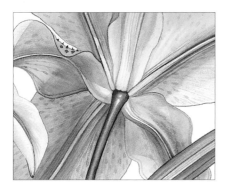

This anemone has beautiful, fine veins on the petals which are gently applied between glazes. The centre of the flower is covered in tiny grey-blue hairs and surrounded by stamens with fine filaments and seed-shaped anthers. The soft central part of the flower is executed first and the stamens then painted around and in front of it.

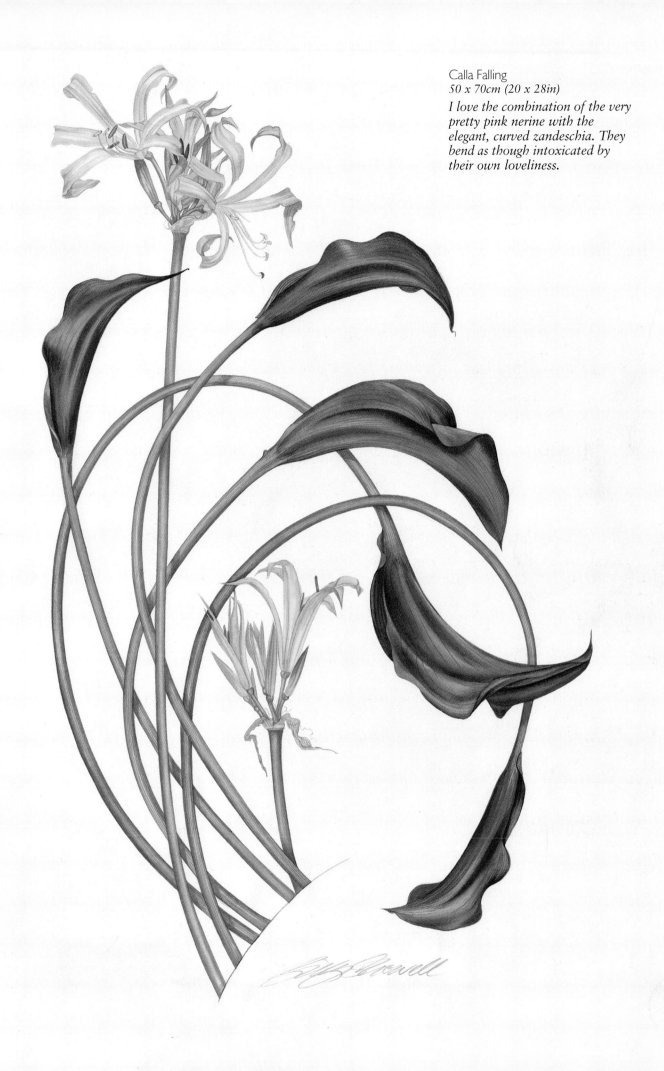

Calla Falling
50 x 70cm (20 x 28in)
I love the combination of the very pretty pink nerine with the elegant, curved zandeschia. They bend as though intoxicated by their own loveliness.

Stamens and carpels

Stamens and carpels are the reproductive parts of the flower and they vary hugely in form. With tall, fine stamens notice first the colour then the width of each part. Sketch them out lightly and then paint the petals around them (you may wish to use masking fluid). Remove the pencil lines and paint them in carefully using subtle washes applied with the tip of a No. 4 brush.

With densely packed stamens, use masking fluid where possible (see page 31). Apply a wash of the background colour, and when dry use a strong mix of paint to carefully lay on the detail with the tip of a No. 4 brush.

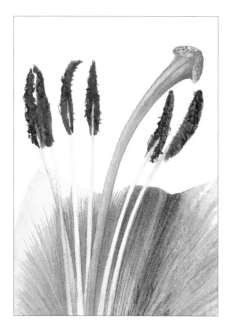

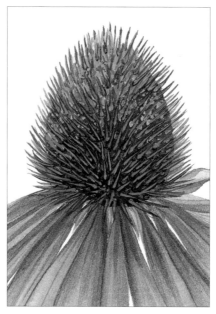

The pollen on the lily anthers (left) was dotted on with a rich mix of cadmium orange.

The centre of the echinacea (right) required many applications of small amounts of intense colour.

Veins

These should be painted on towards the end of the painting, just before the unifying wash. Use the very tip of a No. 4 brush and use light, sweeping strokes. Make sure they taper towards the end.

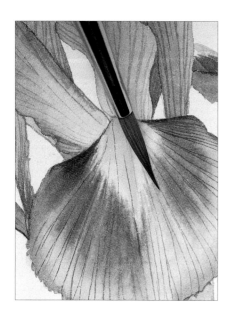

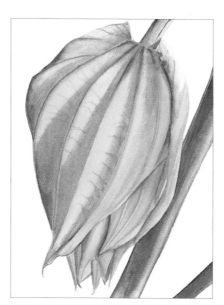

The fine veins on the iris petal (left) help to describe the petal's gentle curve. Good observation is required to obtain the correct direction and fanning of the veins.

This medinilla bud (right) has subtle veins, which show up intermittently. They help to illustrate the concave nature of the longitudinal sections of the bud.

44

Texture

The texture of petals in many cases is defined by the light. The stronger the highlights, the more glossy or waxy the petals will appear to be. A softer, more tinted highlight gives the petals a delicate, mat appearance. Overlapping pale washes can produce a transparent effect. Any raised detail with shadow will convey a rough-textured surface (see page 30).

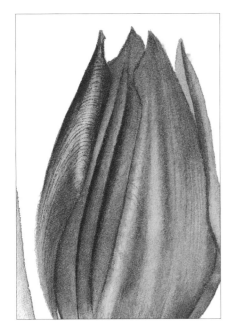

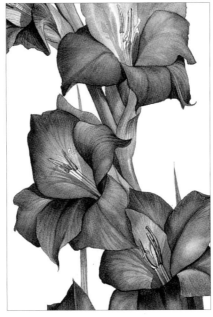

As the tulip petals (left) curve into the bud, their thick, waxy surfaces catch the light. The strong highlight accentuates their texture and shape.

The soft, mat petals of the gladioli (right) have no strong, bright highlights, but the colours in shadow are given a deeper intensity.

Markings

If a flower has distinct markings, mix the colour required and apply it carefully. Do not use the dry brushing method. Try to maximise the mark-making ability of the brush to create the correct shapes.

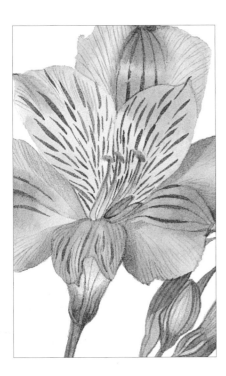

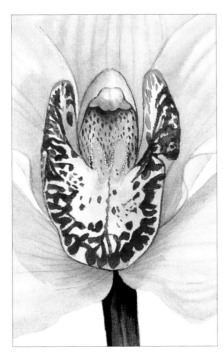

The distinct markings on this Peruvian lily (left) have smooth and clean shapes. You can create these shapes by using the point of the brush and applying the paint lightly at first, then pushing down a little before lifting the brush up at the end.

This orchid (right) has definite markings around the lip. I sometimes find it helpful to relate the shapes to familiar objects – that way I find them easier to illustrate and map out.

45

Painting the stamens and carpel of an amaryllis

The amaryllis has large, smooth stamens growing around a central carpel. The stamens separate slightly as the flower matures. Sections of the petal behind are visible, and I find it easier to paint these in before painting the stamens. Any minor mistakes can then be painted over. I use a No. 4 sable brush for painting very small details.

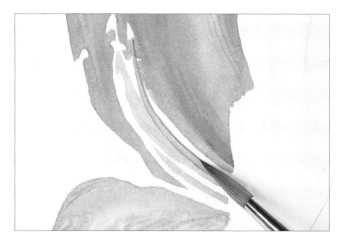

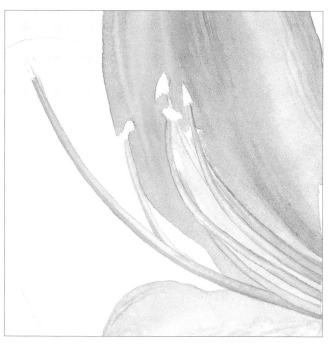

1. Begin by painting in the petal behind the stamens. When the petal is dry, glaze one stamen at a time with water and lay on the colour immediately. Make the stamens paler towards the tips. While the paint is still wet, and using the very tip of the brush, drag a darker tone down either side of each stamen to create light and shade.

All the stamens and the carpel mapped in.

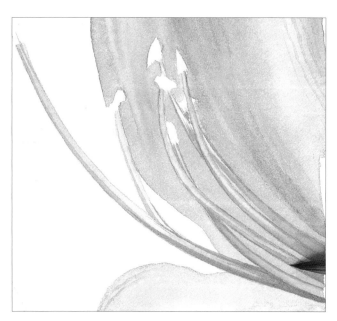

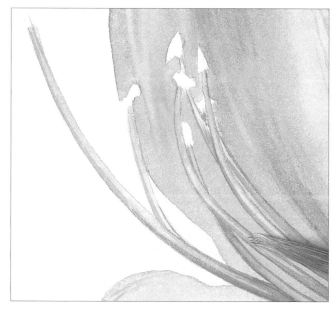

2. Make a stronger mix and strengthen the colour on the darker areas of the stamens and carpel, particularly around their base. Allow the paint to dry completely.

3. Add fallen pollen to the stamens and carpel using a fairly strong mix of titanium white and cadmium yellow pale applied using the dry brushing method.

Adding veins to the amaryllis bud

Before you begin painting, study the pattern of the veins. Practise achieving the correct width of vein using the tip of your brush. I usually apply the veins after the first or second wash of colour, then when they are totally dry glaze over the top of them to soften the edges.

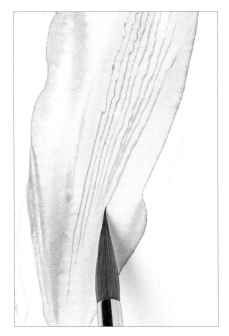

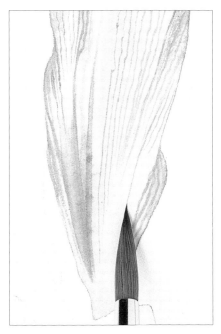

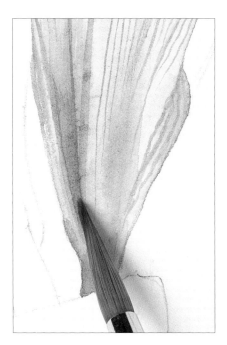

1. Mix your colours fairly wet so that they glide across the paper. Paint the green veins on the bud using the very tip of the brush, 'wiggling' it slightly as your brush travels down from the tip of the bud to its base.

2. Continue with the pink veins on the pink part of the bud. Again, 'wiggle' the brush and lift it smoothly off the paper as you reach the end of each vein.

3. Add dark pink washes towards the base of the bud. Soften these washes into the rest of the bud with a clean, damp brush.

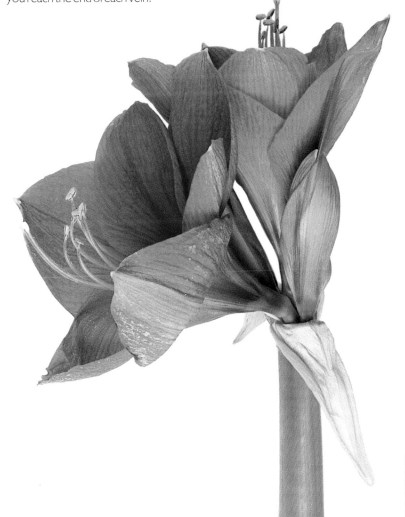

4. When the veins are dry, continue painting the bud by laying on extra glazes of colour.

Painting leaves in detail

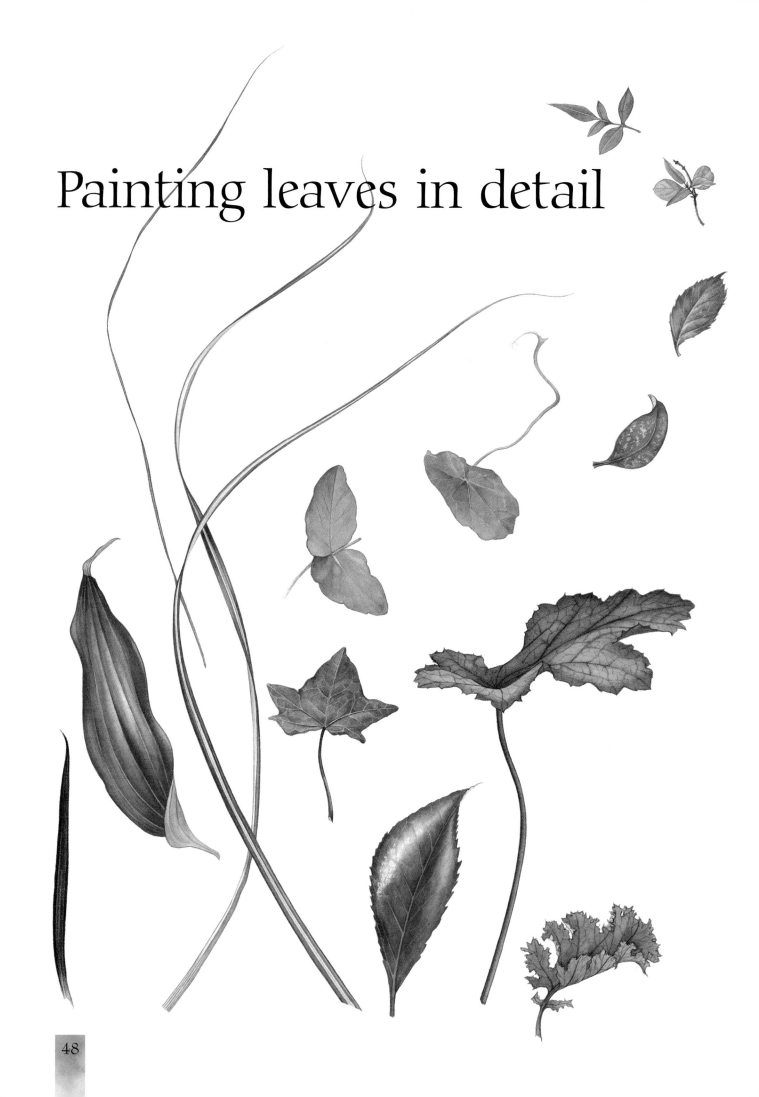

There is a wonderful array of leaves to paint, varying dramatically in shape, size, colour and texture. The level of surface detail you include in your painting is down to personal choice, but I find the veining, spots or bloom are usually just too beautiful to ignore.

In flower portraits, the function of the leaves is to complement the flowers, and you should compose your painting with this in mind. Use the leaves to create a sense of drama or elegance; to enhance the tone of your painting. Include all the leaves you can see, even those behind the flowers. These can be painted in less detail but will give your picture depth. As leaves often survive longer than the blooms, they can be painted in after you have completed the flowers and buds, though this is not a hard-and-fast rule.

As with flowers, leaves can be tackled in stages. Start with the light. Does the leaf shine and have a glossy appearance, or is it mat? The light falling on a leaf can sometimes obliterate the detail, and at other times it can accentuate it. Apply the highlights in the first wash, and once these have been established add the veins and patterns. These can then be glazed over to blend them in with the background and make them appear more natural.

In your painting, try to capture the essence of the leaves, make them as realistic as possible, and enjoy the way they make your flower portraits come to life.

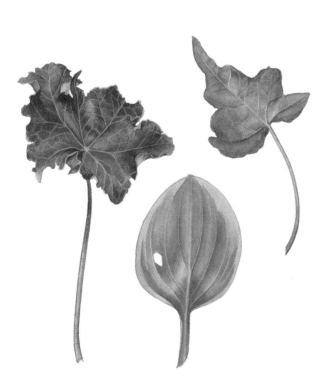

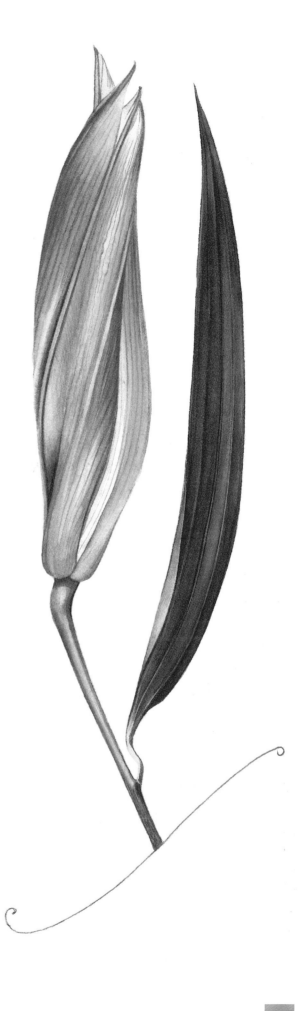

The colour of this eucalyptus leaf was created using a small amount of white with cerulean blue tone and cadmium yellow pale. Add in the veins using the same green with a little French ultramarine added to it. Finally, lay a little white on top for the chalky bloom.

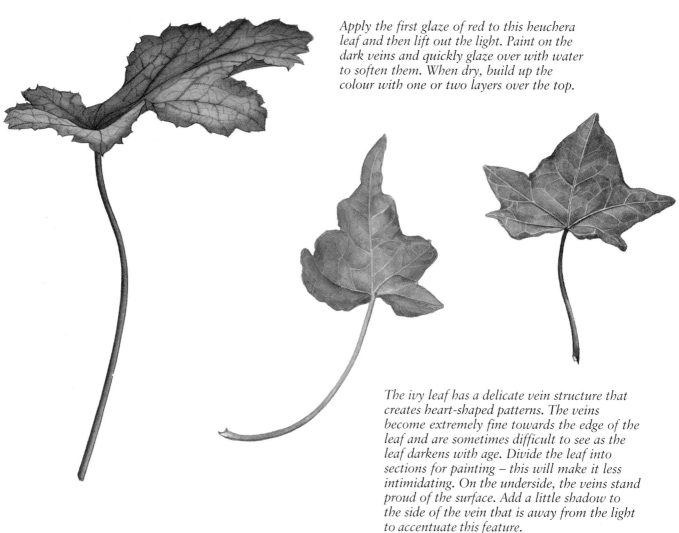

Apply the first glaze of red to this heuchera leaf and then lift out the light. Paint on the dark veins and quickly glaze over with water to soften them. When dry, build up the colour with one or two layers over the top.

The ivy leaf has a delicate vein structure that creates heart-shaped patterns. The veins become extremely fine towards the edge of the leaf and are sometimes difficult to see as the leaf darkens with age. Divide the leaf into sections for painting – this will make it less intimidating. On the underside, the veins stand proud of the surface. Add a little shadow to the side of the vein that is away from the light to accentuate this feature.

Both the lily leaf and the variegated hosta leaf have elongated, parallel veining. Apply the paint along one side of the vein and soften it into the highlight. Leave a small space for the vein that tapers away to the tip.

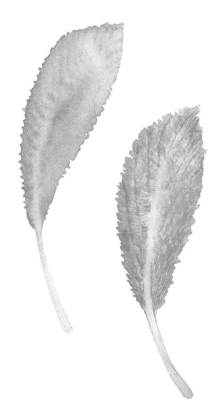

For the first stage of this leaf (*Stachys byzantina*) use a mix of French ultramarine and cadmium yellow pale dropped on to a wet glaze to create texture. The highlight is retained along the midrib by lifting out the paint while it is still wet. For the next stage use the same mix of green and apply the colour in little hair-like strokes, following the pattern on the leaf. The final stage is to use titanium white mixed with cerulean blue tone and apply the paint with the very tip of a No. 4 brush to create the soft, hairy surface.

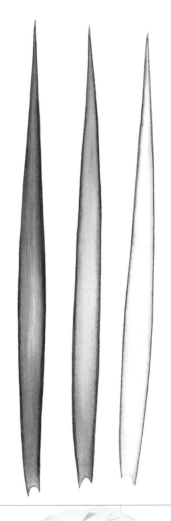

For the long, thin leaf on the right, the first stage is to glaze the leaf shape in water and apply alizarin crimson mixed with French ultramarine along both edges. The second stage is to glaze again with water then lay on a wash of cerulean blue tone mixed with cadmium yellow pale. Lift out the highlight in the centre. Finally, apply fine lines of the same green but with a hint of French ultramarine. Allow these to dry, then apply a final glaze of the same mix and soften it towards the highlight.

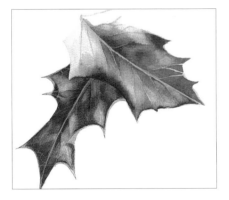

Before painting this holly leaf, study the pattern, count the points, and draw it as accurately as you can. When you then apply the paint you can spend less time observing and more time blending and moving the colour around. Work from the point into the body of the leaf.

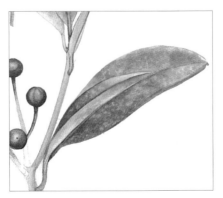

For this dappled skimmia leaf, apply the light yellow-green base then, when it is dry, lay a water glaze and spot on the green to create pattern.

The first stage of this variegated holly leaf is to lay a pale wash of yellow, then paint in the veins. Between each vein, paint on the dark green and lift out the highlight. When dry, use darker mixes of green to paint in the dark green pattern and slim down the veins.

Veins

Veins, though functional, create beautiful, intricate patterns in contrasting colours that are a joy to paint. Observe them carefully before and during your painting, taking note of their direction and relative widths. Remember: always observe what you see, not what you think ought to be there.

 I paint on veins using the tip of a No. 4 sable brush. I map out the main veins first and then branch out from them with smaller, finer veins. If you cannot achieve a fine, continuous line, complete each vein in sections. Lift your brush off with a gentle sweep partway along the vein, then reapply it in a similar manner and with a small amount of overlap to ensure a seamless join. Repeat along the length of the vein. (This technique is demonstrated on page 54.)

Leaf rubbings

To achieve complete accuracy in your leaf drawing, or to reproduce a particularly complex veining pattern, it may be possible to take a leaf rubbing and work from that. Not all leaves are suitable for this – some are too soft or too delicate – but if your leaf is sturdy enough to withstand the rubbing process, it can be extremely useful.

 Lay the leaf on a sheet of newspaper, place tracing paper or tissue paper over the top of it and rub gently but firmly over the top with a soft, blunt, HB pencil.

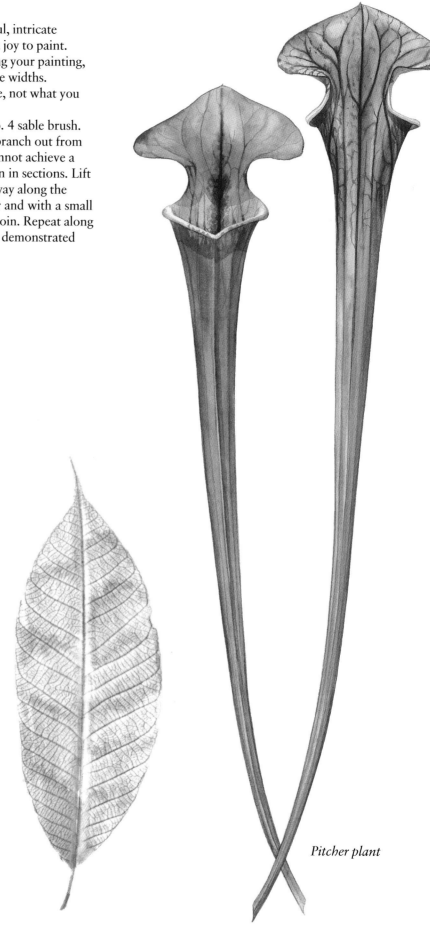

Pitcher plant

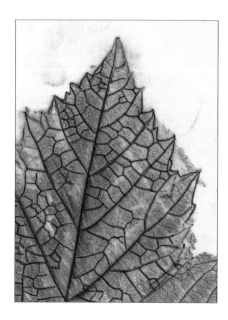

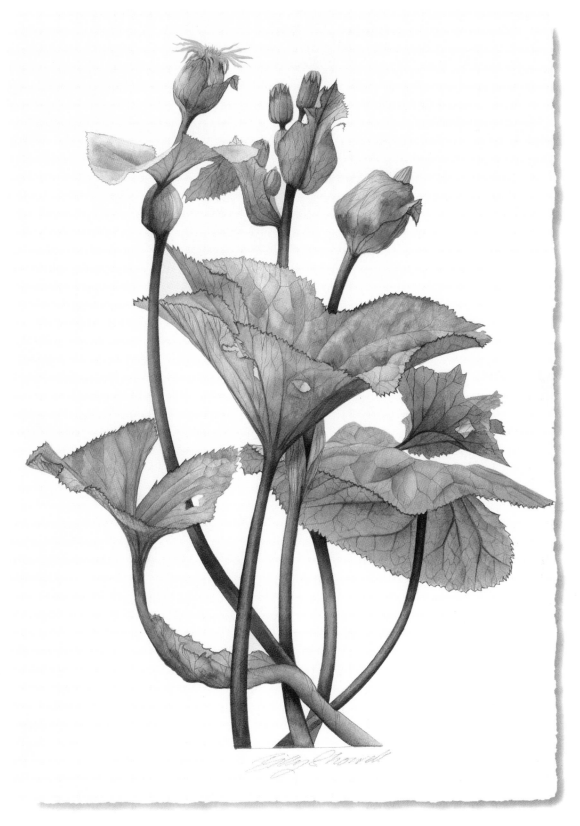

Ligularia

50 x 70cm (20 x 28in)

*The veins are the most striking part of the ligularia plant.
The larger leaves pucker between the veins to create pockets
of light. On the smaller, flatter leaves the light has bleached
out the veins on the upper surface, but shines through to
reveal the beautiful pink blush of the veins beneath.*

Large leaves

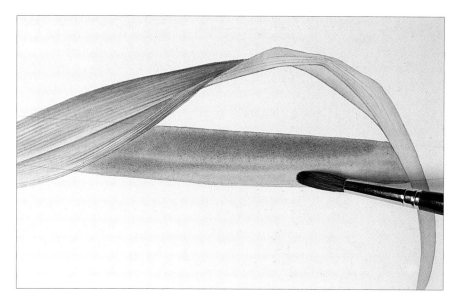

Tip

If your plant is very long and narrow, you may find it easier to turn your painting sideways and work from left to right.

1. Apply the first wash using a large, round, sable or mixed-fibre brush. Here, I have painted one side of the leaf darker than the other following the shadowing on the leaf.

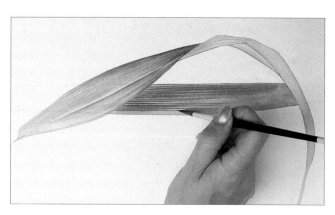

2. Using a No. 6 brush, paint in the parallel veins and ridges. It is difficult to keep a steady hand for the full length of the leaf, so sweep the brush along from the base then gently lift it off about halfway along.

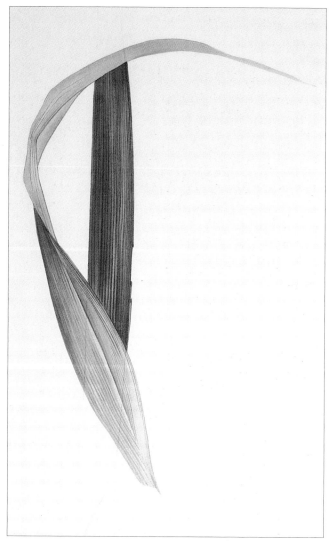

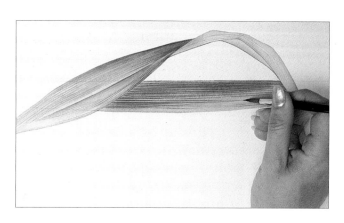

4. Apply two finishing glazes of mid-green, and complete the torn edge of the leaf with a No. 4 brush.

3. Complete the veins from the centre of the leaf to the tip.

Small leaves

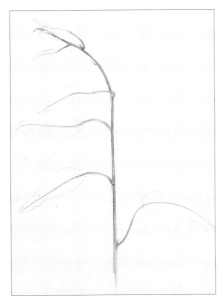

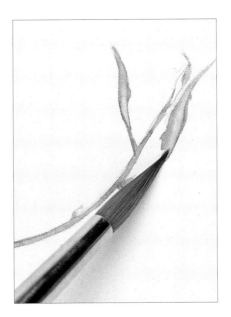

1. Begin by painting the stems and midribs of the leaves using the tip of a No. 6 brush.

2. For the tiny leaves at the top of the stems, use a strong mix of fresh green painted straight on to dry paper. Lift out any highlights. For the backs of the larger leaves, glaze the paper with water and then lay on a light wash of bright green over the top. Again, lift out the highlights.

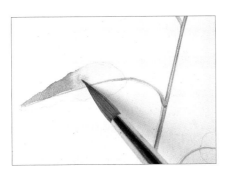

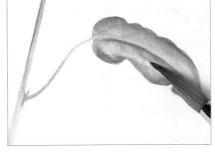

3. For the tops of the leaves, lay a clear water glaze and drop in a richer green. Lift out the highlights. When the paint is dry, rub out the pencil lines.

4. Add surface details using the tip of the brush, such as the thin shadow just beneath the midrib and the slender veins.

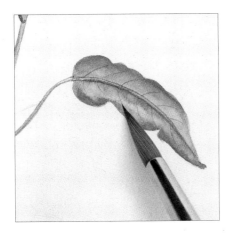

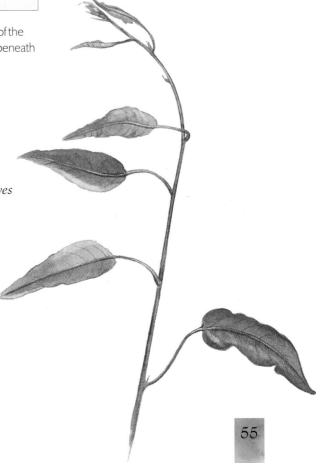

The completed leaves

5. Apply another wash of colour, and strengthen the colour where needed.

Painting stems in detail

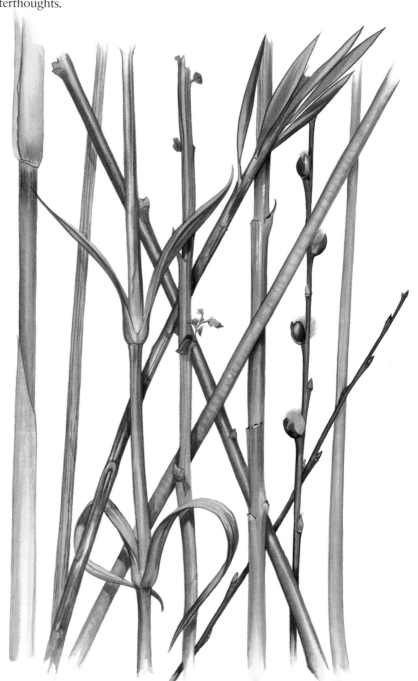

I love long-stemmed flowers. They suit my compositions and I enjoy the subtle variations in colour created by shadow and the roundness of the stem. When painting a stem, it is important to maintain a continuous highlight along its length. Paint a section at a time, glazing with water before putting on the colour. Take the glaze beyond the part you are painting to ensure the paint blends seamlessly with the next section. For the smooth edges of the stems it is essential to achieve clear, sharp lines. Thorns, sepals, hairs and leaf joins should be painted in as an intrinsic part of the stem and not added in as afterthoughts.

Ligularia stems are a lovely dark pink-red. The tone changes along their length, and the enveloping leaf joins curve and lighten as they catch the light.

Nerine stems are long and slender, tapering towards the flowers and curving very slightly from the base.

Amaryllis stems are large and fleshy and have a hollow centre. They have very fine, parallel veining and a soft bloom.

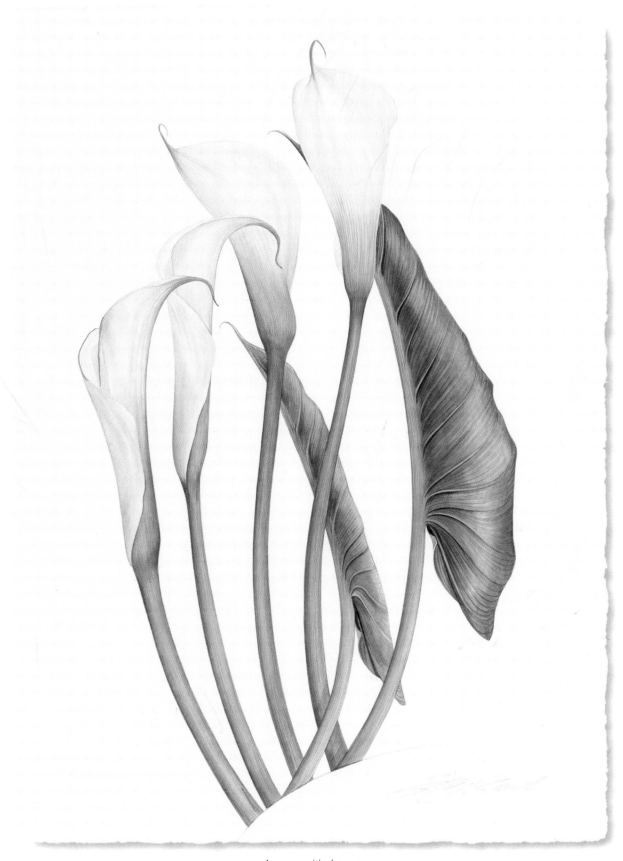

Arums with Leaves

50 x 70cm (20 x 28in)

These arum lilies grow well in my garden and I paint a lot of them. I particularly like the leaves before they open, and the height and elegance of the stems – their complementary curves allow me to create dynamic compositions.

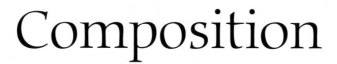

Composition

Composition is the most important element of a painting. It draws in the eye and moves the viewer to look closer or harder. As an artist, I like to compose my flower portraits in ways that are aesthetically pleasing yet have an air of unpredictability about them. I like pictures to be slightly 'weighted' at the base so that the image sits well in one position. This can be achieved by giving the illustration more space around the image, allowing you the flexibility to adjust its relative position when it is mounted and framed.

Weighting can also be achieved by the simple addition of a signature, title, description or some other text, which may form part of the design from the outset. But a word of warning here – only the most proficient calligrapher should attempt to add written text or a title to their work. One often sees examples of this badly done, sometimes with mistakes, which will make an otherwise good painting worthless. I have developed a habit of including a pencil line in many of my paintings (see, for example, page 113). This originally came about as a way of finishing off the stems but has now become something of a signature mark within much of my work.

The process by which I design my compositions begins with inspiration from the world around me. I sketch ideas and images in a notebook and refer to it when designing my paintings in the studio. Nature often needs no assistance in arranging a composition, and provides me with a perfectly composed plant so that all I have to do is to place it artistically on the paper.

You need to decide from the outset what you wish to include in your picture. You may decide to paint not just the flower, but also the bulb or root (see page 83), perhaps adding other foliage or flowers that complement your subject. You also need to consider at which stage in the plant's life cycle you wish to paint it, for example a tightly closed bud or a fully opened flower, and should it be painted with or without imperfections? I sometimes choose to show many views, or different life stages, of the same plant or flower (for example, pages 38–39).

In my painting, I try always to capture an image of the flower frozen in time, as you would if you were taking a photograph, to create a portrait of it that is a faithful reproduction of the living plant. My aim is to capture the plant's essential beauty, and I feel I can only do this if I love the flower I am painting.

Whatever your approach, composition is fundamental to a finished picture appearing complete and aesthetically pleasing. Begin by sketching out several small versions of the picture before you put pencil to paper. Good planning prevents you making mistakes and having to use an eraser on the delicate surface of your paper. A good tip is to draw the flower on to sketching paper first and then trace over the drawing. You can then position the tracing accurately on your watercolour paper before transferring it.

I like to give an illustration an overall shape. This gives me a theme for a series of paintings, which often leads to new ideas for the next series. I start by sketching up the flowers within various shapes and see which design suits them best.

Composition is not just about the arrangement of the flowers, it is also important to consider where you place your images on the paper. You need to allow a comfortable amount of space around the image for mounting and framing, with slightly more space at the bottom than at the top. This prevents the painting from looking as though it is falling out of the mount.

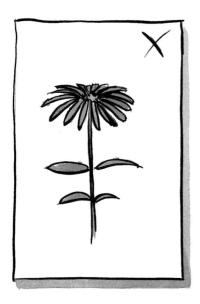

When painting a single bloom, think about the overall shape and size of the finished painting. If you draw the flower in the centre of a large sheet of paper a lot of the paper will be wasted when you cut it down for framing.

One way to position a single flower is to place the image in a corner of the sheet of paper and perhaps shorten the stem. The image will then be a more pleasing size and shape for framing.

If you are painting a longer-stemmed flower, try drawing it to one side of the sheet of paper to create a tall, narrow picture. But be careful not to start your painting too near the edge of the paper, as some of the image may be lost beneath the mount.

Draw a light, dotted, pencil line around the outside of the picture to define the edge of the frame, and to remind you not to paint beyond it.

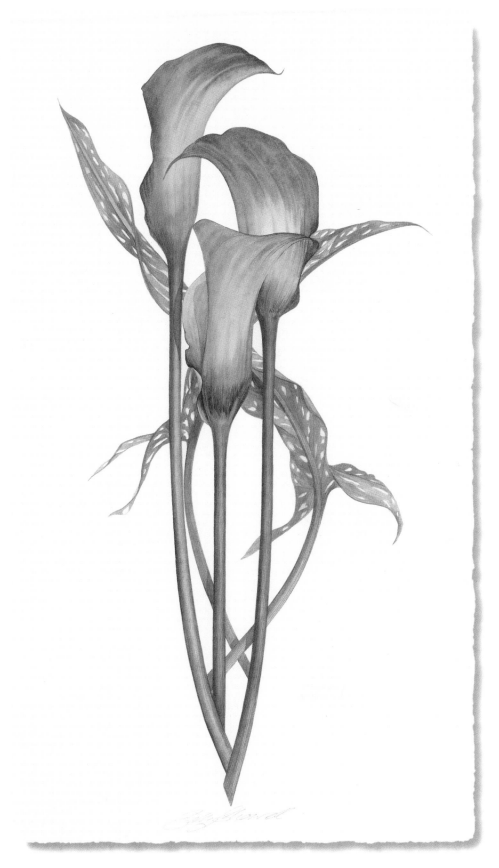

Three Callas with Leaves
50 x 70cm (20 x 28in)

These zantedeschia have elegant, spotted leaves
that I have crossed behind the three, proud and
erect flowers to soften the composition.

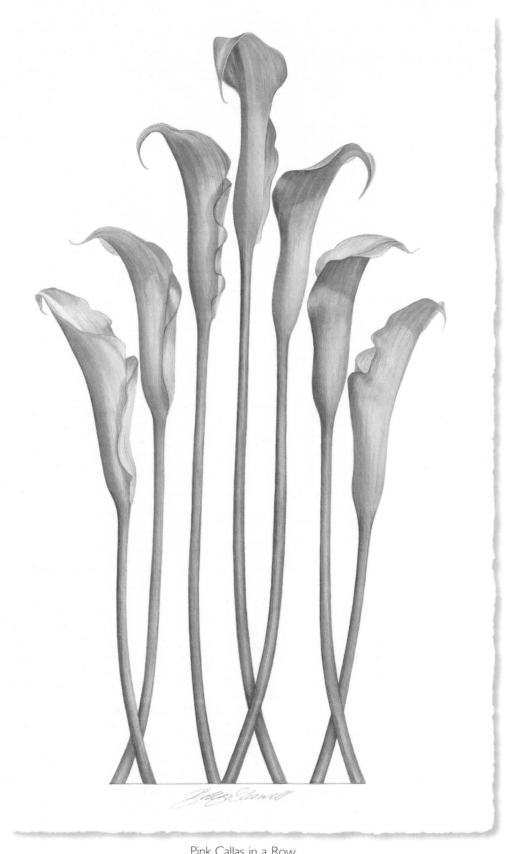

Pink Callas in a Row
50 x 70cm (20 x 28in)

I love the gentle curves of these calla lily stems – I arranged them so that they crossed over at the bottom, creating little crosses like Roman numerals.

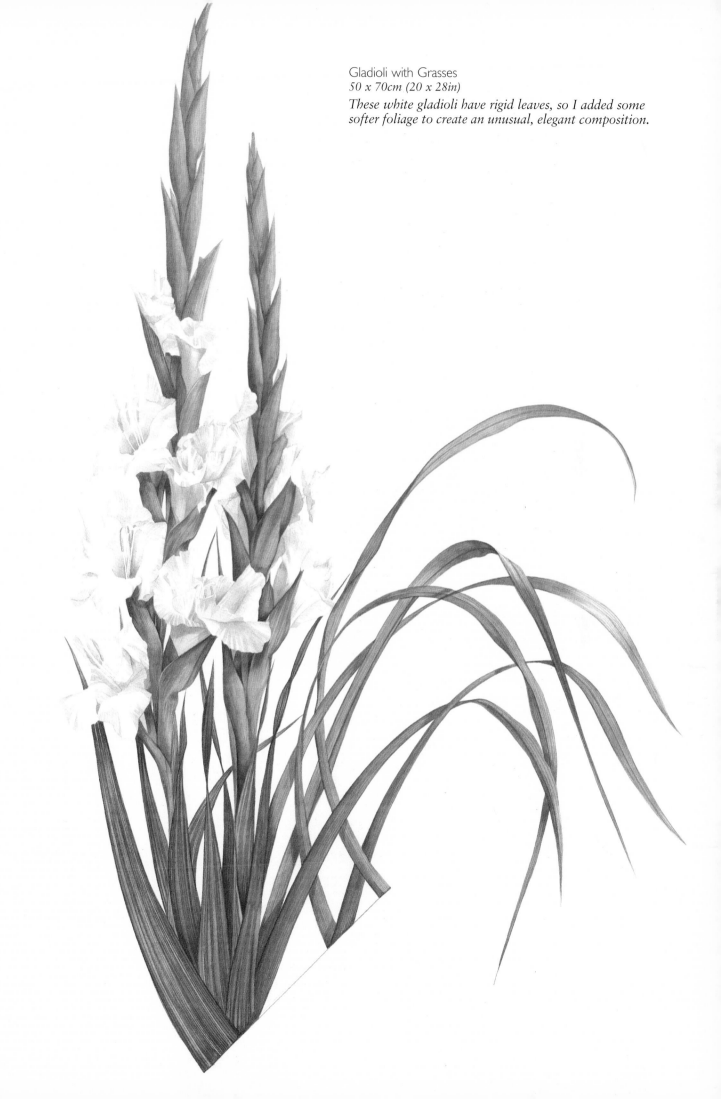

Gladioli with Grasses
50 x 70cm (20 x 28in)
These white gladioli have rigid leaves, so I added some
softer foliage to create an unusual, elegant composition.

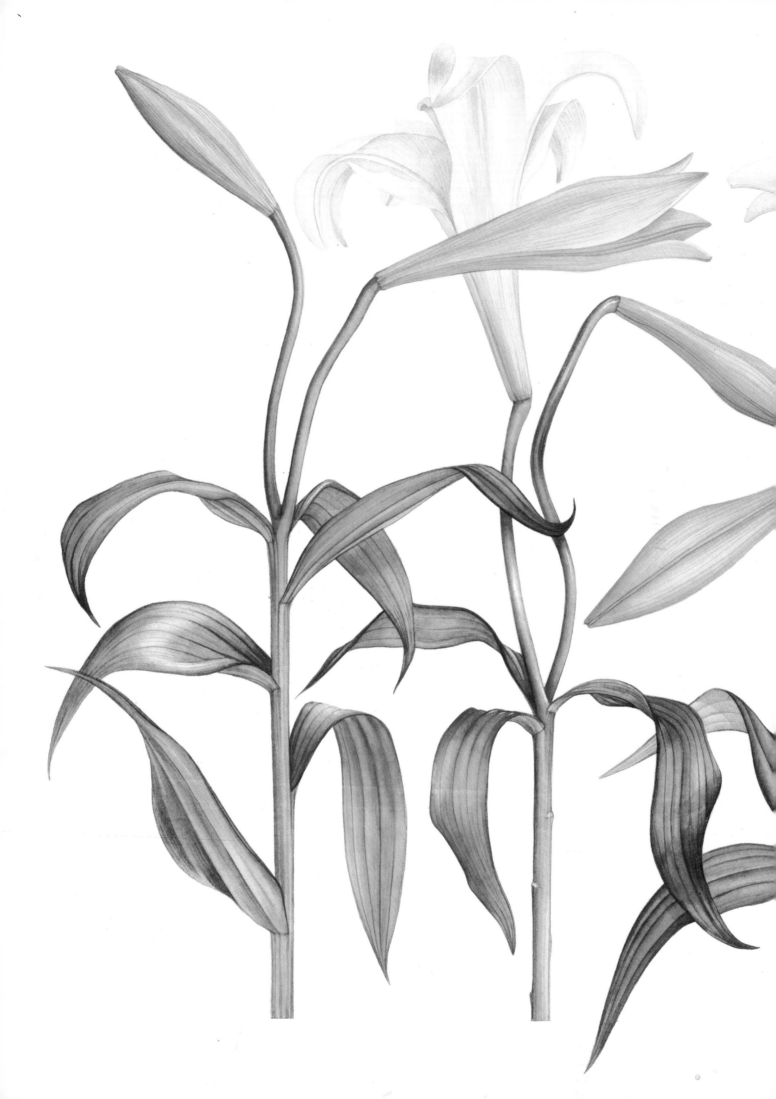

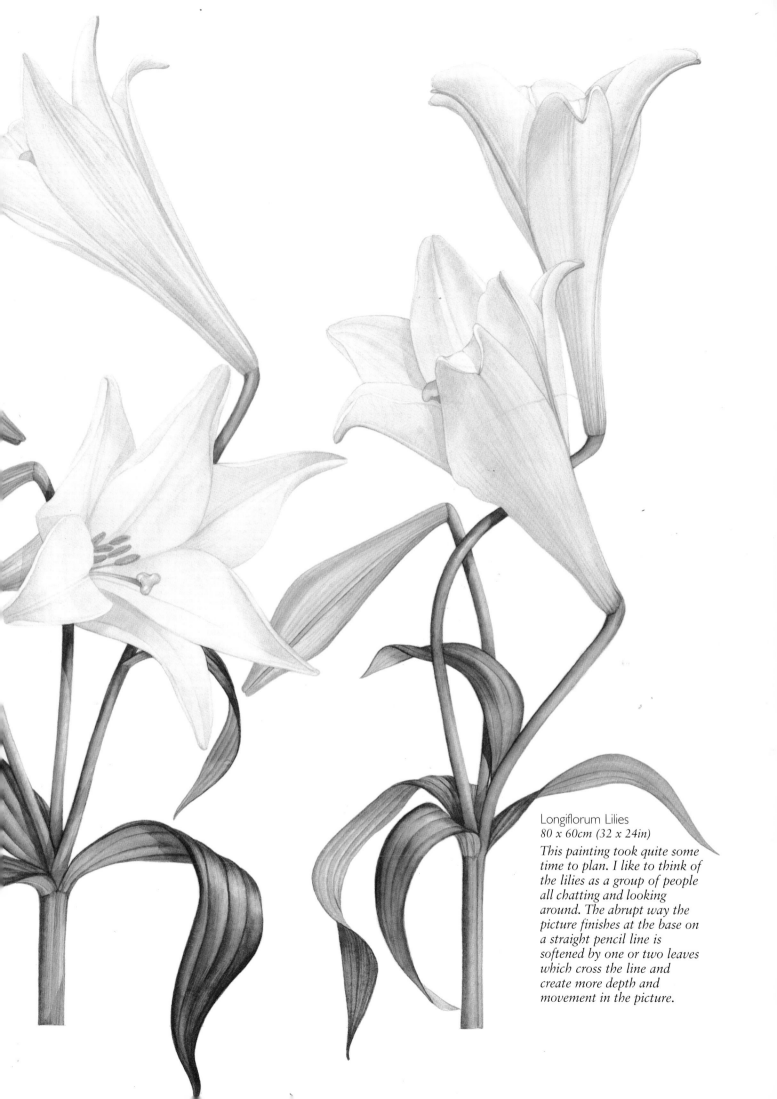

Longiflorum Lilies
80 x 60cm (32 x 24in)

This painting took quite some time to plan. I like to think of the lilies as a group of people all chatting and looking around. The abrupt way the picture finishes at the base on a straight pencil line is softened by one or two leaves which cross the line and create more depth and movement in the picture.

Projects

There follow four step-by-step projects of four very different flowers. Each project includes a variety of techniques which, once mastered, can be applied to any flower you choose to paint. Virtually all the techniques used have been covered in more detail elsewhere in the book, and cross-references to these are given where necessary.

I have tried to be as detailed as possible in my explanations of what to do at each stage, including the shape and angle at which to hold the brush, and which colour mixes to use. If painting your own flowers, use these mixes as a guide only and mix colours that are true to your specimen.

You may take several days to complete a project, during which time you will need to keep your flower in good condition. Cut flowers will last longer if they are kept cool, and stored in a garden shed or in the fridge overnight. A cut bloom will need water so I put the end of the stem into a small, rubber-topped phial containing water so that the flower and leaves do not wilt.

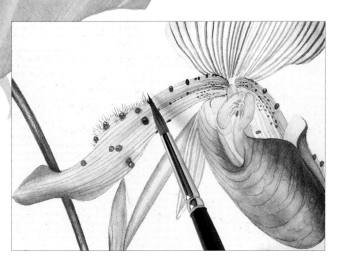

Slipper Orchid, page 68

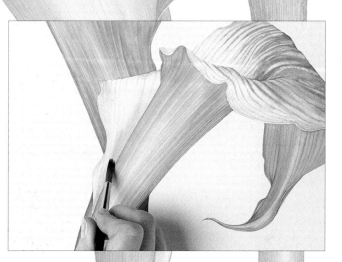

Green Goddess Lily, page 86

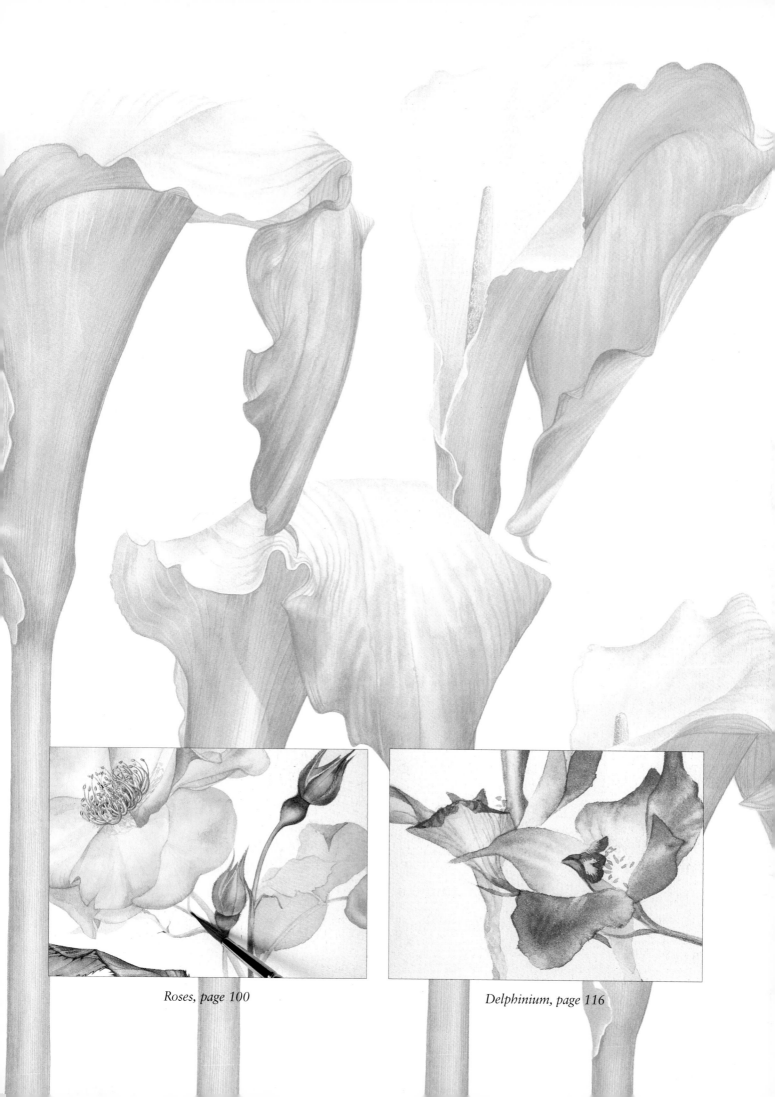

Roses, page 100

Delphinium, page 116

Slipper Orchid

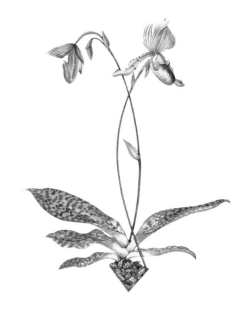

You can buy slipper orchids from garden centres and florists towards Christmas time. I cannot resist these fanciful flowers – their rich colouring and exotic, well-defined form make them ideal subjects for painting. The name 'slipper orchid' comes from the shape of the pouch-shaped petal (the lip) and suits them perfectly. The flowers last for days, so there is plenty of time to perfect your painting.

For this composition I chose two plants – one fully opened and one semi-opened – and placed the roots in a V-shape containing bark.

Before you begin to paint, gather together all the equipment you need, and mix your basic colours (listed on the right) prior to glazing.

Materials

Sheet of hot-pressed watercolour paper, 50 x 60cm (20 x 24in)

Sharp, HB pencil

Pencil eraser or putty rubber

Pencil sharpener

Roll of absorbent kitchen towel

Scalpel

Sable paintbrushes, No. 4 and No. 6, with extra fine points

Watercolour paints in alizarin crimson, cadmium lemon, cadmium red deep, cadmium yellow pale, cerulean blue tone, French ultramarine, indigo, mauve, permanent rose and titanium white

Basic mixes

Basic pink
alizarin crimson, permanent rose, mauve and a little French ultramarine

Basic light green
cadmium yellow pale and cerulean blue tone

Basic dark green
cadmium yellow pale, French ultramarine, cerulean blue tone and cadmium lemon

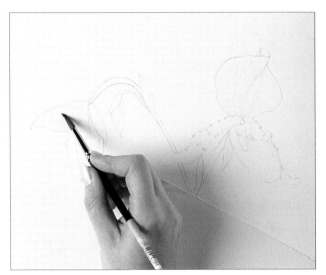

Drawing the outline.

1. Draw the outline of the flowers (like a silhouette) with a sharp, HB pencil. You can also draw in some details, but only if they are to be painted dark and will therefore be covered by the paint.

Laying a clear water glaze.

2. Decide which flower you wish to paint first, then lay a glaze of clear water over one part of it. Choose a part of the flower that is predominantly pink, as you will be laying the pink wash first. Use a No. 6 brush and be careful to stay within the pencil outline.

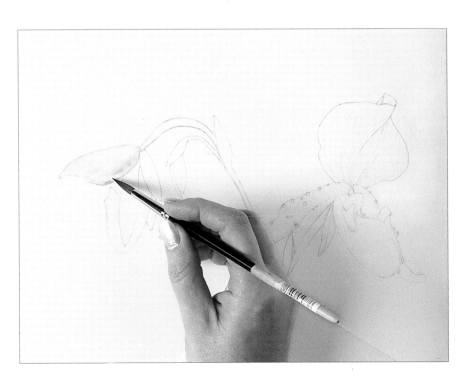

Laying the first pink wash.

3. Lay a wash of the basic pink mix over the clear water glaze while it is still wet. This is known as the wet-into-wet technique (see page 26). To create highlights and to control the spread of colour, use a clean, damp brush to lift out the paint. When the colour on the first shape has dried, add the clear water glaze to the next one and repeat the process until you have completed all the pink parts of the flower.

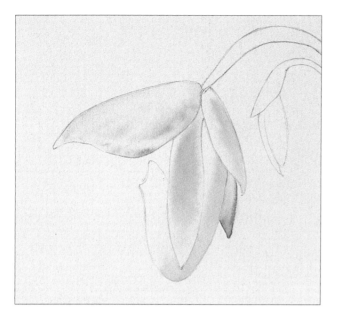

Tip

While the two washes are drying, blend the two mixes together with a damp brush.

4. *Laying the first green wash.*
Repeat steps 2 and 3 for the green parts of the flower using the basic light green mix. As before, once each shape has dried, apply the clear glaze of water to the next shape, followed by the colour wash.

Allow these first glazes to dry.

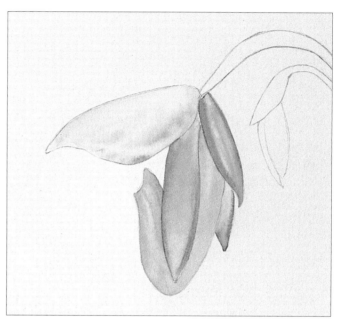

Building up the layers.
5. Lay another glaze of water over the first colour and apply the second colour. Blend the two colours together where they merge. Allow each wash to dry, then continue to apply thin layers of colour washes. When the first flower's initial glazes are finished, allow it to dry.

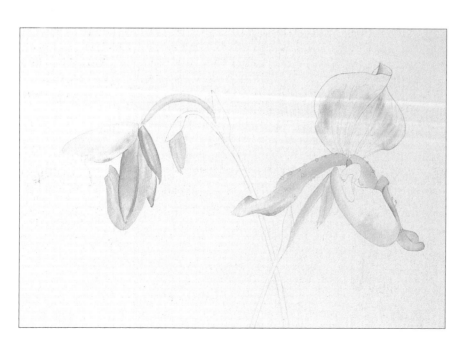

Painting the second flower.
6. When the washes are absolutely dry, rub out the pencil marks around the painted flower. Paint the second flower in the same way. Where the flower has a white edge, leave on the pencil outline until the shadows have been applied.

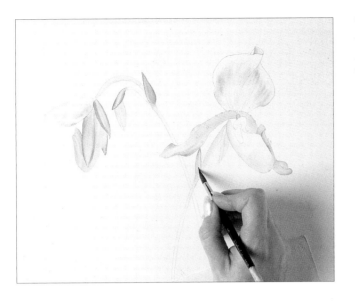

7. Paint the remaining flowers, sepals and bud using the same techniques as in steps 3–6. For the sepals, add French ultramarine and a little cadmium red to the basic light green mix. Laying a clear water glaze first, apply the colour. Drag the glaze down the stem a little way to avoid a hard line between the sepals and bud and the stem. Lift out the highlights with a damp, clean brush.

Tip

Always work from left to right of your painting (if you are right-handed), and from top to bottom.

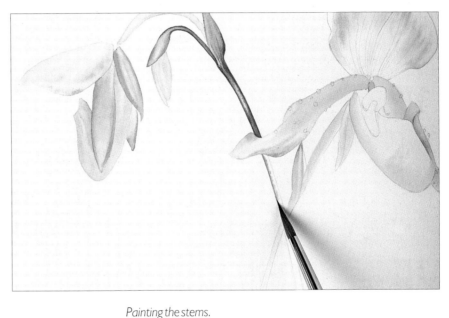

Painting the stems.

8. Make a mix of permanent rose, mauve, French ultramarine and a little cadmium yellow pale for the stems. Again using the wet-into-wet technique, glaze the stems with water and then paint them. Start by laying a strong wash down one side of the stem so that it is bleeding towards the centre, then repeat on the other side. Drag the point of a clean, slightly damp brush down the centre of the stem to create a highlight. You may have to do this several times to lift the paint off.

Tip

Never lick your brush – many paints contain poisonous compounds.

Adding texture to the stems.

9. Use the dry brushing technique (see page 29) to add texture to the stems.

71

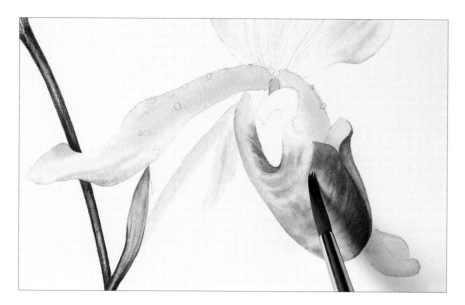

Building up the layers.

10. Start to build up the layers on the flowers. Starting with the fully opened flower, apply a clear glaze down the centre of the lip, where the light hits it. Paint on a richer mix of the basic pink, following the curve of the petal, and dragging the paint into the wet highlight. Do the same with the green from underneath. Soften any edges of the wash with a clean, damp brush to achieve a soft blend.

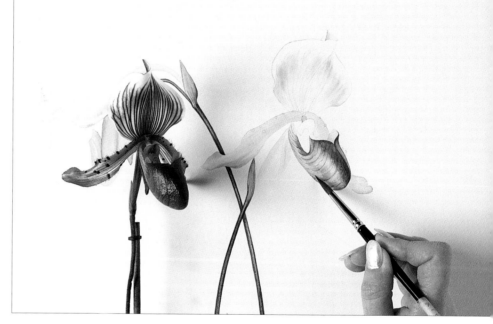

Applying the surface detail.

11. Add some more French ultramarine to the basic pink mix (this makes it darker and more purple), and using the very tip of the brush start to apply the fine surface veining to the lip of the flower. (For paler veins, use a more watery wash.) The veins change from red to green as they go round the petal, so start with the darker pink mix and finish with the basic light green.

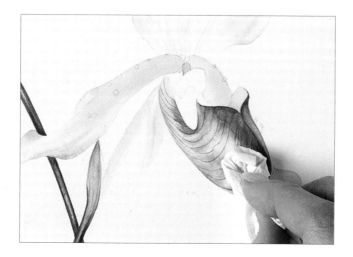

Softening the veins.

12. When the veins are drying, soften them by moistening them first and then lightly dabbing them with a piece of strong, absorbent kitchen towel.

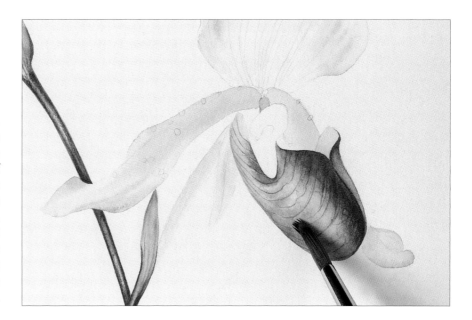

Applying a unifying wash.

13. When the surface detail has dried, use light brush strokes to apply a very pale, even wash of dark pink over the darker areas of the flower. Soften the leading edge of this wash with water as you approach the highlight. When the dark pink wash is dry, repeat with the green. This will soften and unify all the detail, and you can repeat the process again once it is dry to create more impact and add 'drama'. Build up as much colour as you need.

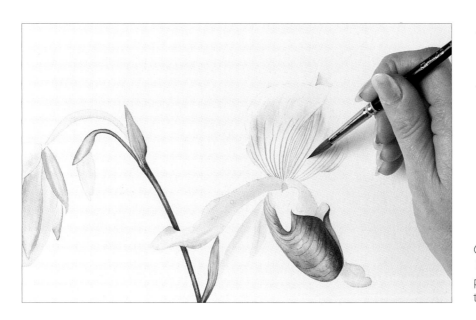

Tip

You may wish to practise the technique in step 13 on a spare piece of paper first!

Continuing to add surface detail.

14. Apply the main green veins to the top petal, using the basic light green mix and the very tip of the brush.

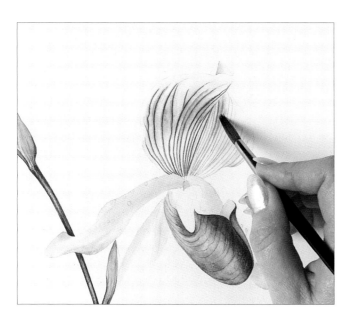

15. Add the pink veins in the same way using the mix used in step 11, continuing from the ends of the green veins. Just before they dry, glaze over them with clear water – this will create a bleed of colour around each vein. To prevent the paint from the pink veins running into each other, paint alternate veins, then go back and paint the ones in-between.

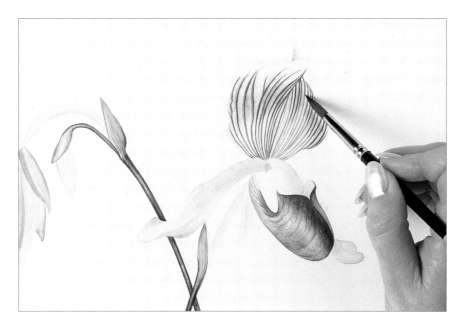

16. When dry, go over the centre of the veins again with a stronger colour to strengthen them up. Use the same colour you used in step 11.

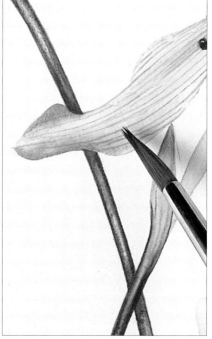

17. For the two slender petals on either side of the flower, build up the colour by laying glazes of the basic light green and basic pink. Soften with clear water as you paint towards the highlight. When these glazes are dry, paint in the green veins with the tip of the brush using a mix of cadmium yellow pale, cerulean blue tone and cadmium lemon. Soften the veins at the base of the petal using a clean, damp brush.

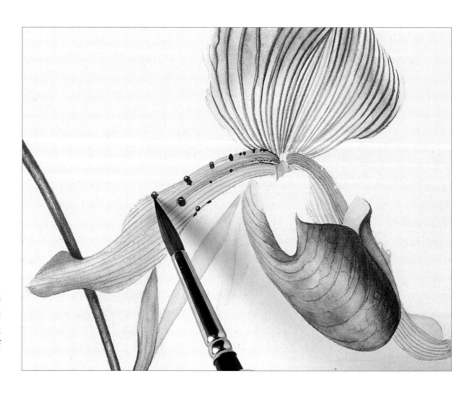

18. Paint the raised spots on the petals using a fairly thick, dark mix of alizarin crimson and French ultramarine. Leave a small dot of white paper in the centre of each one for the highlight.

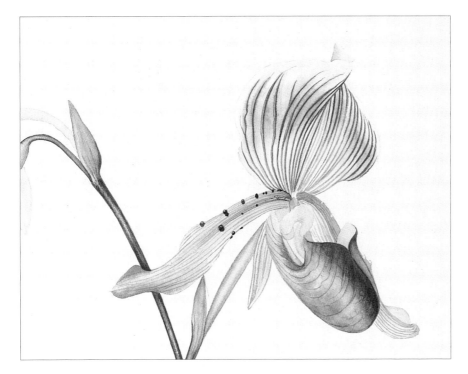

19. Complete the small petal lying behind the lip using the tip of the brush. First block in the pale colours using light washes of the basic light green mix and a light glaze of permanent rose, then map in the details and strengthen the washes as required.

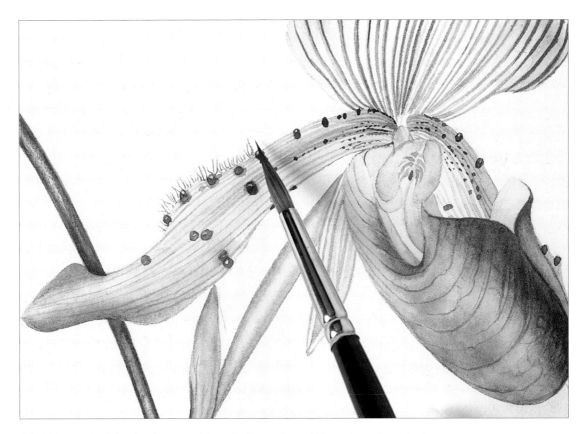

20. Using a mix of alizarin crimson and French ultramarine, add the veins and spots to the centre of the flower using the very tip of the brush. Apply the paint in small patches to strengthen the colours where needed. Soften the edges with a clean, damp brush.

Using a No. 4 brush and a strong, fairly wet mix of cadmium red deep and French ultramarine, paint in the hairs on the petals and stem using a single, light stroke, going from top to bottom, for each hair.

21. Paint the dark pink and green veins on the bud, working down the bud using the tip of the brush. For the green, use a mix of cadmium yellow pale, French ultramarine and a little cadmium red deep. For the pink, use the darker pink mix (see step 11).

When they are dry, make a watery mix of cadmium yellow pale, cerulean blue tone and a little cadmium red deep, and drag this wash lightly over the whole bud. This softens the veins and blends them in with the rest of the plant. While the wash is still wet, drop in a little more pink or green to strengthen the colour. Add the hairs as before.

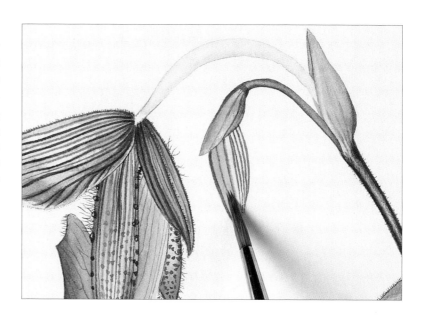

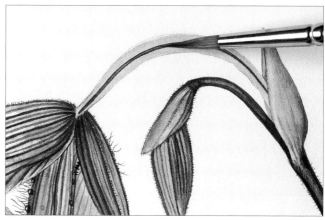

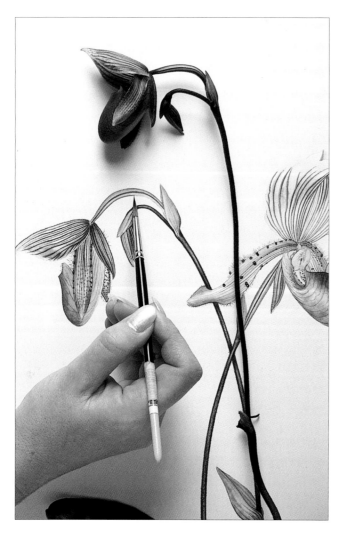

22. Add the main vein to the ovary (the stem-like structure joining the flower to the main stem) using the basic pink mix and a darker mix of French ultramarine and alizarin crimson with a touch of cadmium yellow pale. You may need to go over this twice to get the right depth of colour. To create a highlight, lift out the paint from the centre of the vein by agitating it using the tip of a damp brush.

23. Glaze the top edge of the ovary with clear water, then apply the basic pink mix to the edge. The paint should blend into the stem and give a 'fuzzy' edge to the pink. If it spreads too much, mop it up with a clean brush. Now do the same for the lower edge of the ovary.

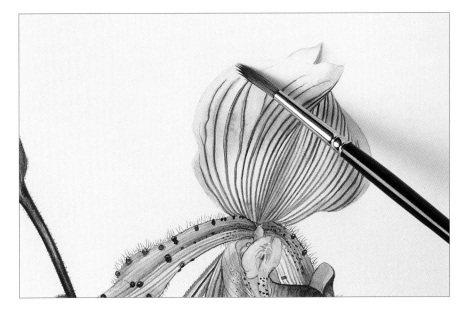

Tip

For each shadow, add a touch of the local colour for a more realistic effect.

24. *Adding shadows (see page 35).*

Add shadows to all of your painting using a basic shadow mix of one part cadmium red deep, one part cadmium yellow pale, and two parts French ultramarine.

Observe carefully where the shadows fall, then apply a watery wash of the shadow mix, softening the edges with a clean, damp brush.

Glaze the edge of the white part of the flower with water before applying the shadow, and soften each application of the shadow mix into the flower using a clean, damp brush. Allow to dry thoroughly, then rub out the pencil marks.

Add a little bit of the basic light green to the shadow mix, and apply shadow to the insides of the flower using the brush lightly.

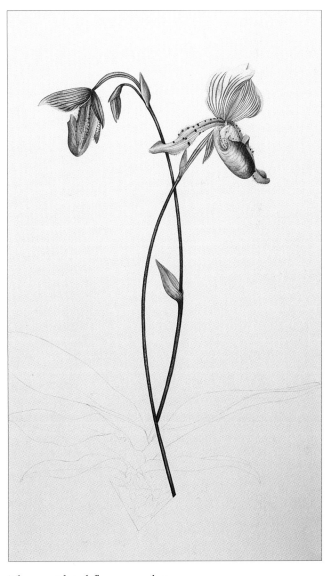

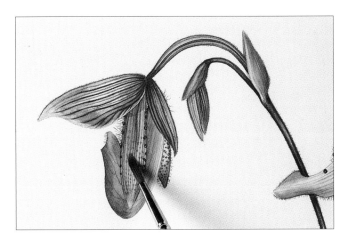

Strengthening the colours.

25. Strengthen the green on the two thin petals to lift their brightness, and add a little more basic light green mix with a little French ultramarine to the sepals.

The completed flowers and stems

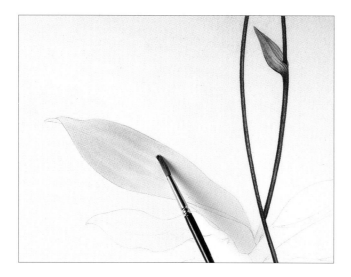

Tip

Always paint leaves in the direction in which they are growing, going from left to right or top to bottom.

Painting the leaves.

26. For the leaves at the base of the plant, use the basic light green mix and the dark green mix. Begin by applying a clear glaze of water over all the leaves using a No. 6 brush, carefully keeping within the pencil outline. While it is still wet, add a background wash of the basic dark green mix.

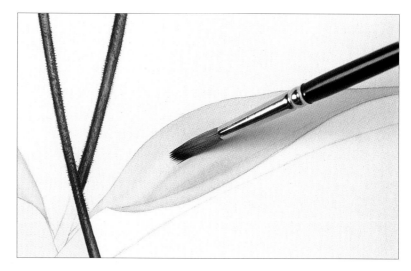

27. While the dark green wash is still wet, use a clean, damp brush to lift out the highlights (if the background wash is too dry, it will leave brush marks, so work quickly). When thoroughly dry, rub out the pencil marks.

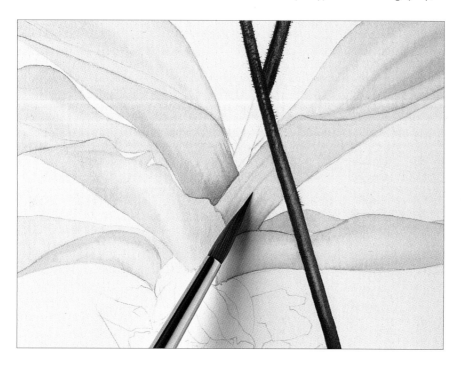

28. Apply a clear water glaze, then with a mix of permanent rose and French ultramarine, add the pink tone at the base of the leaves.

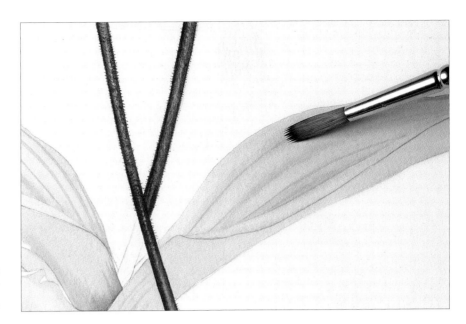

29. Add the veins using the dark green mix, and soften them by dragging over the top with a clean, slightly wet brush.

30. Block in the leaf pattern on the upper leaf surface using the dark green mix with a small amount of indigo added to it.

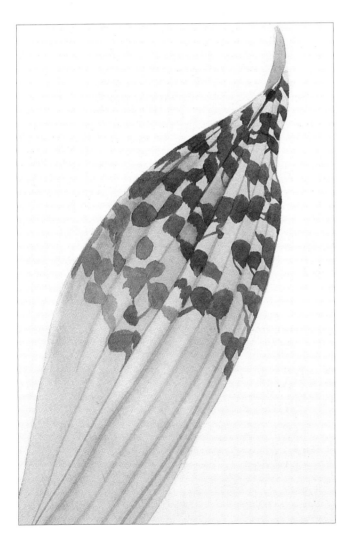

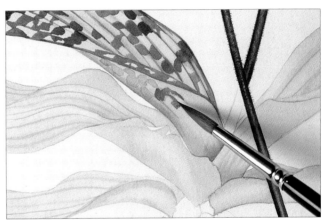

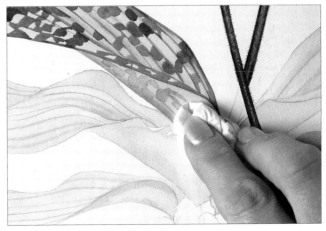

31. To add the pattern to the leaf underside, block in the shapes and then blot them approximately ten seconds later with a piece of absorbent paper. This will make the pattern look faded and more natural.

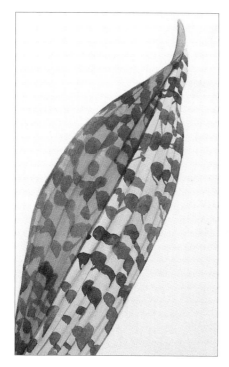

32. Once the pattern on the upper surface has dried, apply a light, even wash of the basic light green mix, first over one half of the leaf and then over the other. Work quickly, in one direction only, and avoid going back over your work. This softens the marks and gives them a more natural appearance.

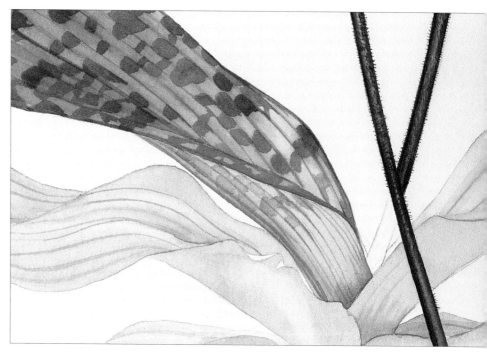

33. To maintain the shine on the top half of the leaf, take the wash down towards the highlighted area, then brush in to this area with a clear water glaze.

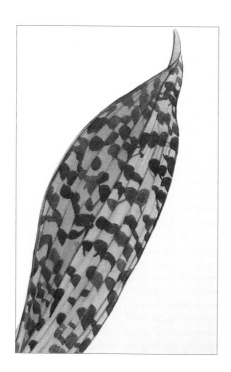

34. Strengthen the pattern with another layer of colour, using a mix of cadmium yellow pale, indigo and a touch of cadmium red deep, and allow it to dry. Redefine the edge of the leaf with a small amount of the dark green mix, and apply a final, coloured unifying wash over the top of the whole leaf using a watery mix of the basic light green.

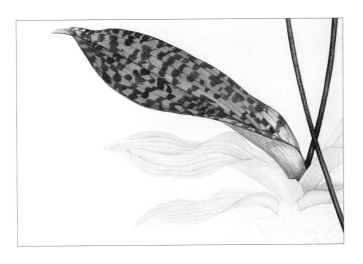

35. Using the basic shadow mix (see page 34) with a touch of green, apply shadows to both leaf surfaces using the same techniques as described in step 24. Afterwards, strengthen the pink at the base of the leaves using a small amount of alizarin crimson applied using dry brushing (see page 29).

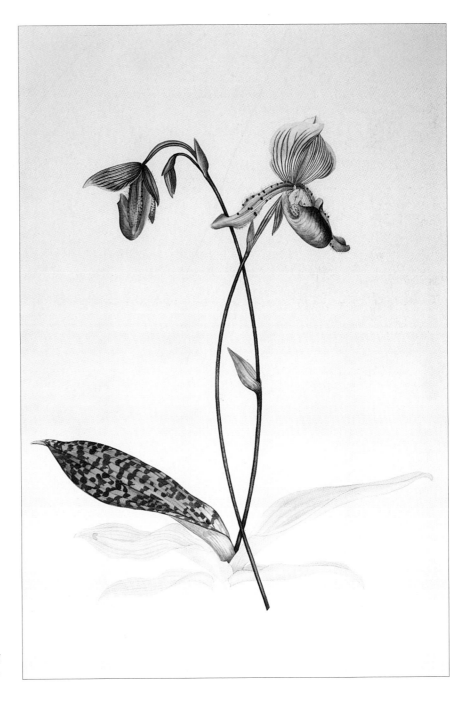

*The half-finished painting showing
the completed leaf.*

Painting the roots and bark.

36. For the roots and bark, use a mix of cadmium yellow pale and French ultramarine for the green roots, and permanent rose, cadmium yellow pale and French ultramarine for the brown roots and the bark. Lighten or darken these mixes as required. First apply a clear glaze, then lay a green or brown wash over the top. Lift out any highlights.

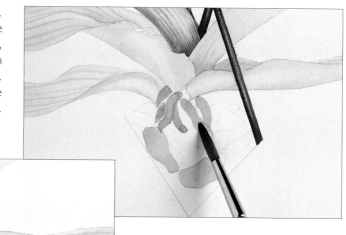

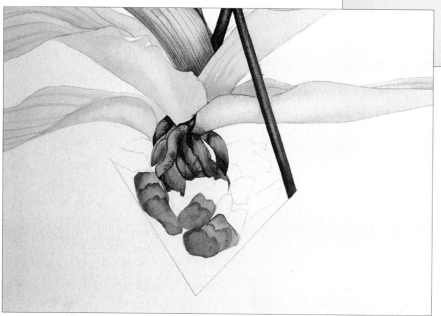

37. For the details on the roots, use the same brown mix with a little more French ultramarine added to it to make it darker, and apply using the tip of a No. 4 brush. Soften the edges of the darker tones with a clean, damp brush, and keep darkening the mixture until all the details have been added to the pieces of bark.

Finishing touches.

38. Add a little alizarin crimson to titanium white and use this to paint in the hairs that are on a dark background, for example where the two stems cross.

39. To give a 'waxy' look to the flowers, create highlights by gently scratching some of the paint off with a scalpel to reveal the white paper underneath (see page 30).

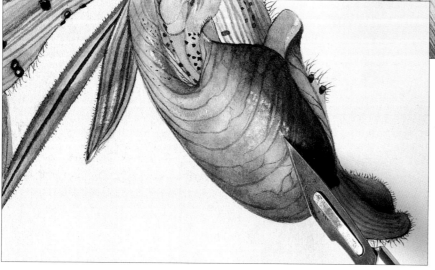

Tip

This must be the last thing you do, as you have damaged the paper and can't paint over it!

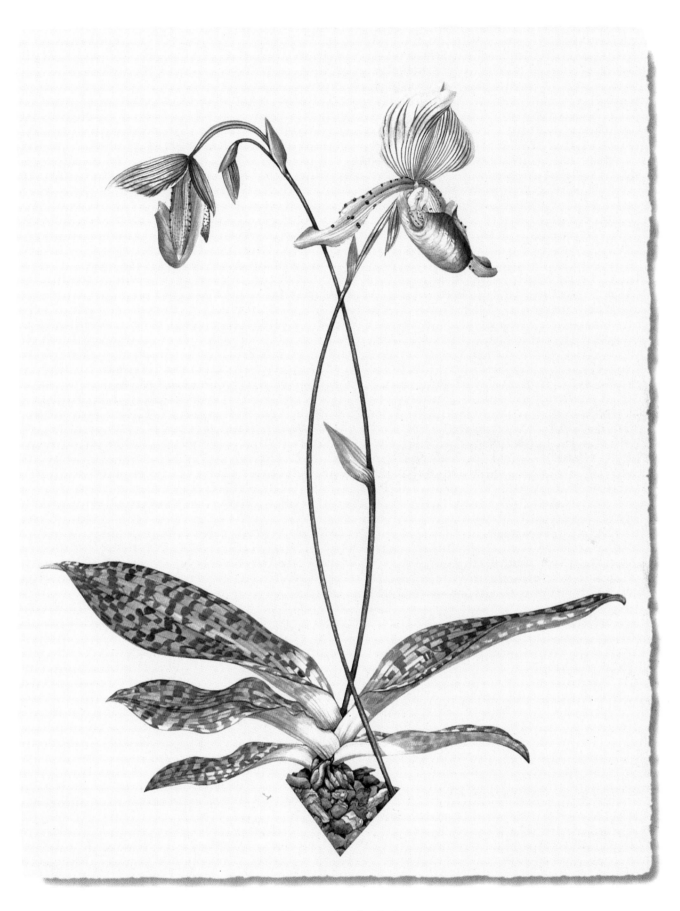

The completed painting

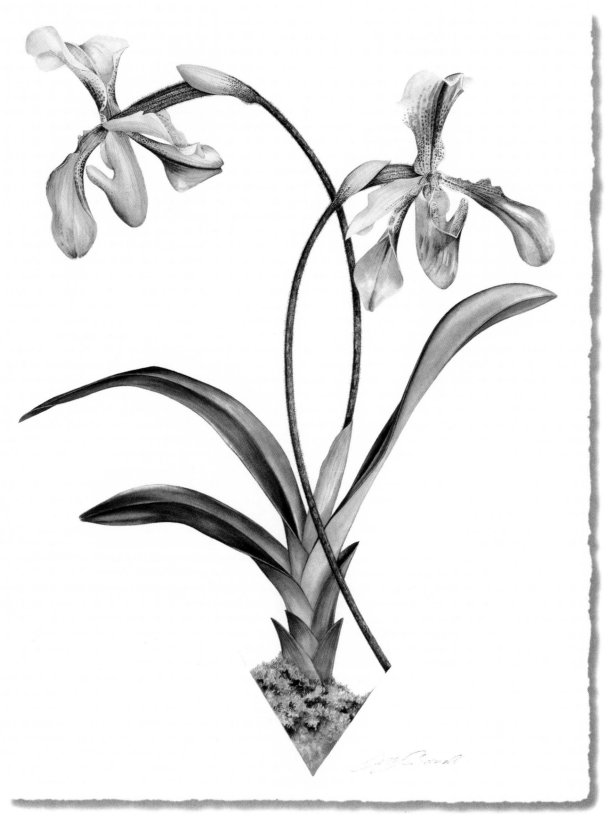

Two Slipper Orchids
60 x 80cm (24 x 32in)

This slipper orchid was the first of a series of paintings in which I crossed two stems. I enjoyed the fact that in each painting I created a new shape. This composition allowed me to paint both the front and the back of the flower.

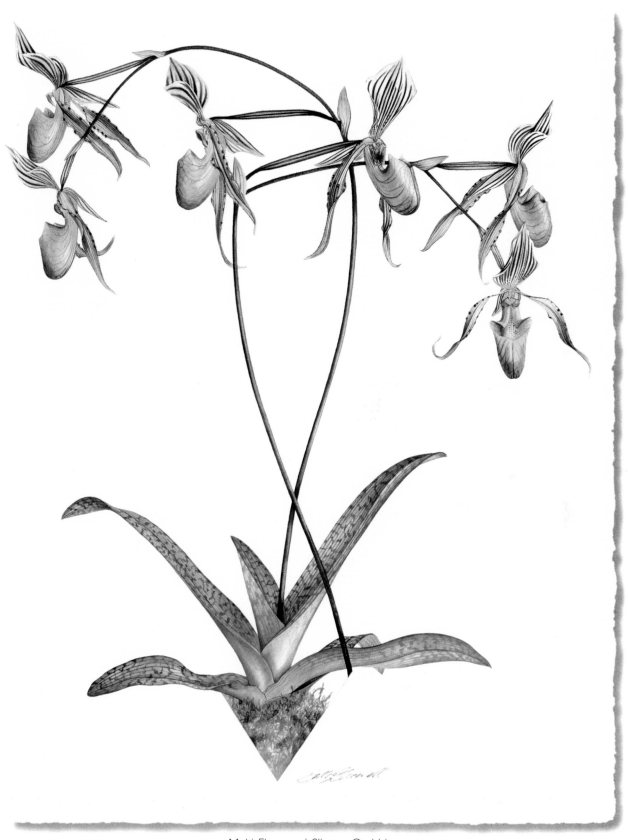

Multi-Flowered Slipper Orchids
60 x 80cm (24 x 32in)

*This multi-flowered orchid gave rise to many views of the
flower, and the plant curved beautifully to create an
interesting composition.*

Green Goddess Lily

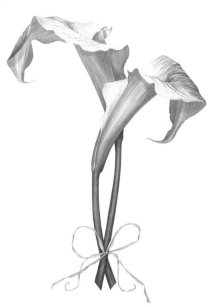

The beautiful flowers first caught my eye at about the time I began painting flowers. I had never noticed them before but they instantly became one of my favourites. They consist of a single, large petal rolled into a cone shape that folds outwards at the top, known as a spathe.

These flowers last a long time when cut, though the green gradually becomes more yellow. They are best kept in water, but I often keep the cut end wrapped in wet tissue or cotton wool and sealed with transparent foodwrap, just while I am handling them during painting.

They seem to like shady, damp areas to grow in, close to water, however I have had little success in finding a spot in my garden where they will really thrive. These flowers are so grand, tall and elegant that simplicity of composition is essential. In this project I have chosen to cross two flowers and tie them together with raffia.

Before you begin to paint, gather together all the equipment you need, and mix your basic colours (listed on the right) prior to glazing.

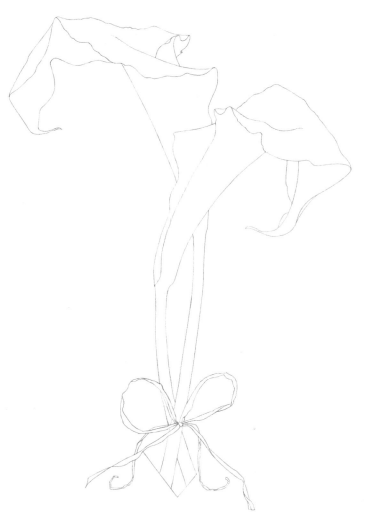

Drawing the outline.

1. Draw two light outlines of the flower, one overlapping the other and facing in the opposite direction, to create the composition. Draw in the raffia bow where the two stems cross. Use a sharp, HB pencil. Remember not to press too hard on the paper, and do not draw in the veins – these will be painted in freehand.

Materials

Sheet of hot-pressed watercolour paper, 55 x 70cm (22 x 28in)

Sharp, HB pencil

Pencil eraser or putty rubber

Pencil sharpener

Roll of absorbent kitchen towel

No. 12 round mixed-fibre brush, and No. 6 and No. 4 round sable brushes with extra fine points

Length of raffia tied in a bow

Watercolour paints in cadmium lemon, cadmium red deep, cadmium yellow pale, cerulean blue tone, French ultramarine, indigo and permanent rose

Basic mixes

Darker green
cadmium yellow pale, French ultramarine and touches of cadmium red deep

Lighter green
cerulean blue tone, cadmium lemon and touches of cadmium red deep

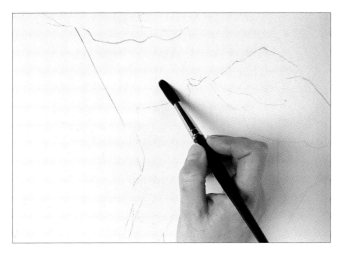

Laying a clear water glaze.
2. Apply a clear glaze to the lower part of the spathe using a No. 12 round brush. Make sure the water is applied evenly over the surface, with no puddles. Glaze only one shape at a time, being careful to keep within the pencil outline. Start with the background flower. Quickly move on to step 3 before the glaze dries.

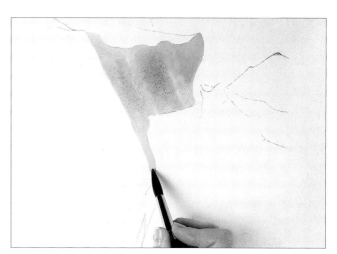

Laying the first wash.
3. While the glaze is still wet and continuing with the No. 12 brush, lay washes of the two green mixes, starting with the paler wash. Gradually lay on colour, and work the two colours together where they blend. Work downwards, from the top of the painting to the bottom.

Tip

When you are painting two overlapping flowers, always paint the background one first.

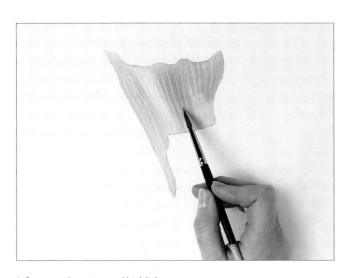

Lifting out the veins and highlights.
4. While the paint is still wet, lift out a highlight using a clean, slightly damp, No. 6 brush. (The paintbrush must be drier than the wash when lifting out veins and highlights.) Lift out the veins using the tip of the brush. Clean the brush between each lift, otherwise you will reapply the paint elsewhere. Allow this flower to dry.

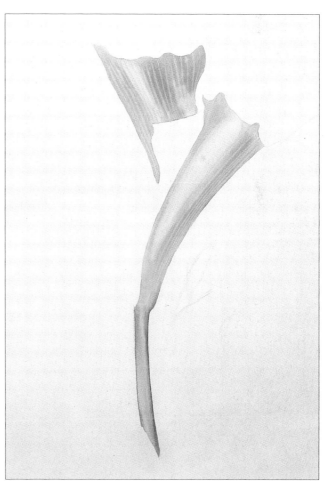

Painting the foreground flower.
5. Apply a clear glaze of water to the second flower and lay on the two green mixes, this time bringing the paint down the stem to the point at which the two stems cross. While the stem is still wet, paint the darker green along the edges of the stem using a No. 6 brush.

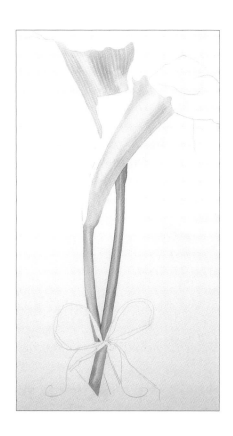

6. *Painting the stems.*
When the foreground flower is dry, glaze with water the stem of the first flower using a No. 12 brush, and lay on the greens using the same method as before (see step 3). Leave the natural highlight down the centre of the stem, lifting out any spreading paint if necessary with a clean, damp brush.
Change to a No. 6 brush and add the darker green along each side of the stem, as in step 5.

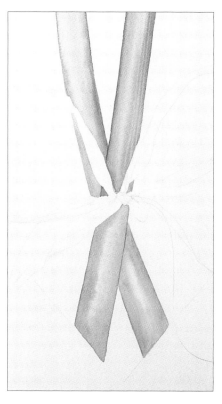

7. When this stem is dry, paint in the lower section of the foreground flower's stem.

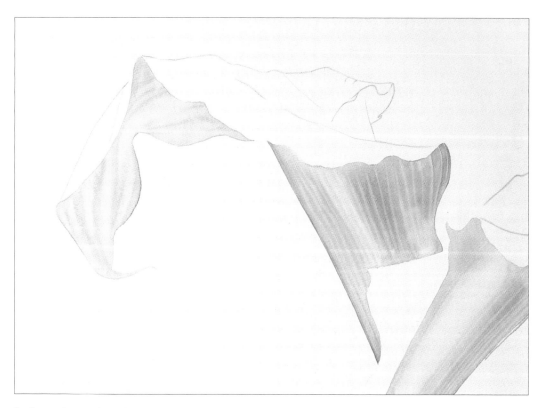

8. *Strengthening the colour.*
When the paint is thoroughly dry, rub out the pencil lines. Mix the two green mixes together to create a mid-green. Use a No. 6 brush to add a clear water glaze to the tip of the background flower, then lay on the mid-green. Drag a clean, damp brush through the wash to lift out the highlights and veins.

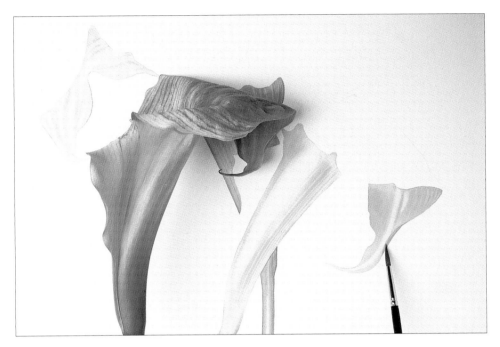

9. Paint in the tip of the foreground flower in the same way, laying colour into a clear glaze of water and lifting out the highlights using a clean, damp brush. While this is wet, drop in an area of shadow by laying the darker green mix along the edge of the tip.

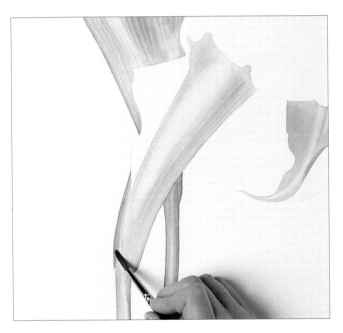

10. Start to build up the colour on the foreground flower. Glaze the lower part of the spathe with water again, then lay on a dark green wash. Avoid losing the highlight along the edge by painting almost to the edge, but not over it.

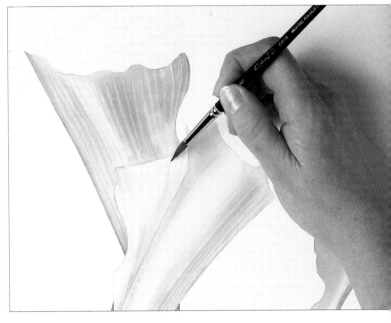

11. For the folded part of the spathe on the left-hand side of the flower, mix a very watery wash of cerulean blue tone and a touch of cadmium yellow pale. Using a No. 6 brush, lay in the wash over a clear glaze of water. Lift out the highlights, then strengthen the mix by adding a little more cerulean blue tone and apply it to the darker areas and veins of the fold while the light wash is still damp. This keeps the lines soft.

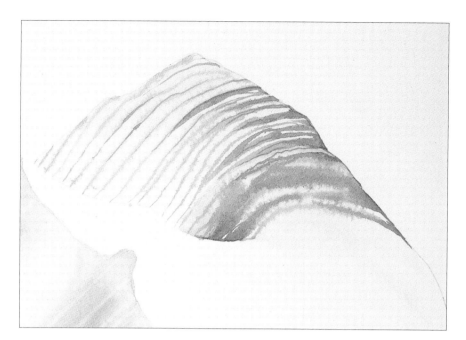

12. Glaze the inner part of the spathe on the foreground flower in the same way (see step 11). Make a strong mix of cadmium yellow pale, cadmium lemon, cerulean blue tone and French ultramarine. While the glaze is still damp, use this mix to paint in the green patterning. Use the tip of a No. 6 brush for fine markings, flattening it out to create wider marks, as shown in the picture below.

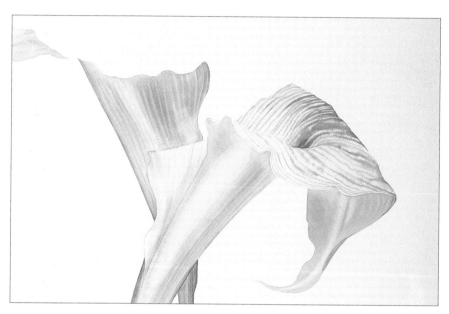

13. Glaze the remainder of the top part of the flower, and paint it following the method used in step 12. Allow the glaze to dry.

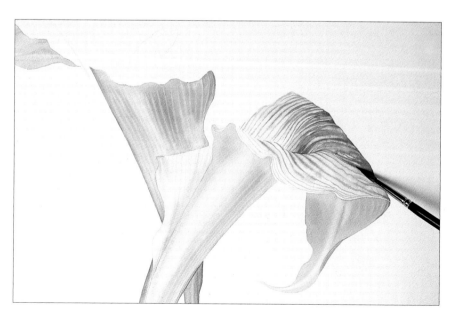

Strengthening the green markings.
14. Apply another water glaze, then use the same green mix and the No. 6 brush to darken the green markings. Paint outwards towards the edge of the spathe. The water glaze allows the markings to stay soft and natural looking. Apply a darker mix to the areas that fall into shadow.

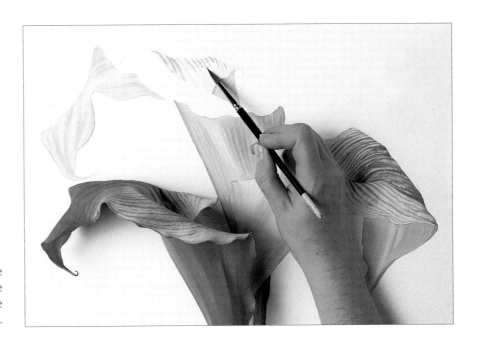

15. Paint the inner part of the spathe on the background flower in the same way – apply a glaze and then lay in the green markings.

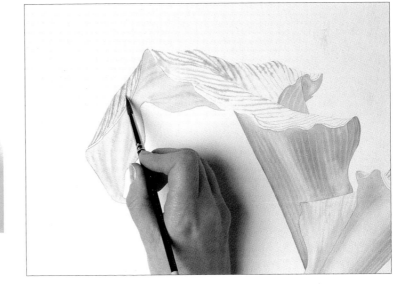

16. Complete the rest of the background flower in the same way.

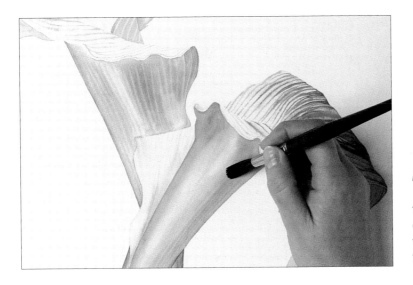

Building up the colour.
17. Build up the colour on the lower parts of the foreground flower. Using a No. 12 brush, glaze down the centre of the flower with water. Then, with the lighter green mix, lay a wash either side of the highlight to intensify the colour.

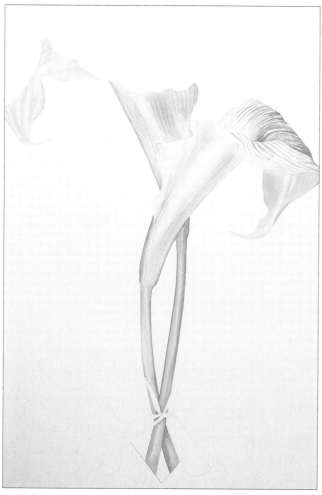

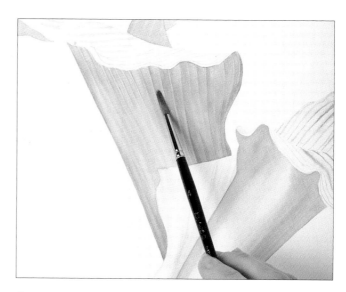

Outlining the veins.

19. Use a No. 4 brush to outline the veins on the upper part of the background flower using the dark green mix. Do this by placing the paint on both sides of each vein, and then softening it on each side with a damp brush. Avoid too much sharp detail in areas where a natural highlight bleaches it out.

18. Build up the colour on the remaining parts of the flowers and on the stems. For the stems, add a little French ultramarine to the mix to strengthen the colour.

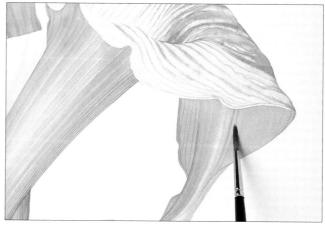

20. Outline the veins on the foreground flower in the same way, including the tip of the spathe. Soften the finer veins by dragging a damp brush gently over the top of them.

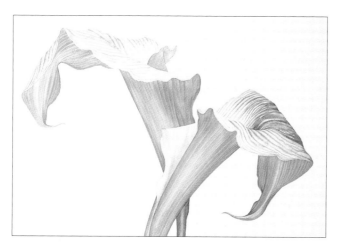

The completed veins on each flower

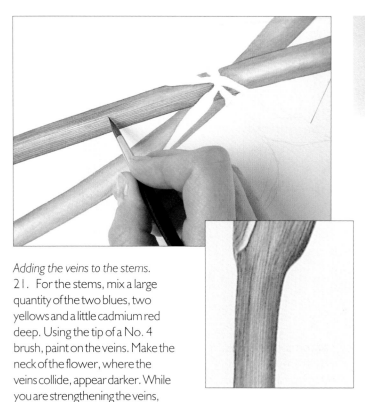

Tip
Change the angle of the paper to make it comfortable for you to work.

Adding the veins to the stems.

21. For the stems, mix a large quantity of the two blues, two yellows and a little cadmium red deep. Using the tip of a No. 4 brush, paint on the veins. Make the neck of the flower, where the veins collide, appear darker. While you are strengthening the veins, sharpen up the edge of the stem at the same time.

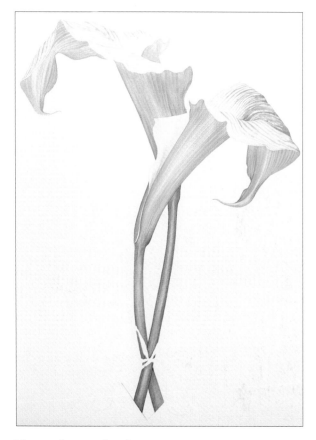

The partly completed painting

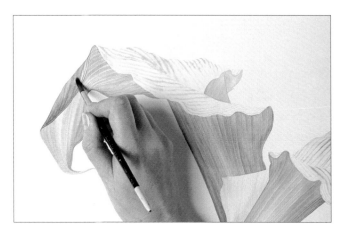

22. Emphasise the small fold on the upper part of the foreground flower by glazing it with clear water, then adding a darker wash of green using a No. 6 brush. Use a mix of French ultramarine, cadmium lemon and a hint of cadmium red deep.

23. Darken the patterns on the inner surfaces of each spathe using a No. 6 brush (see step 12). Use the dark green mix. 'Wiggle' the brush slightly as you work to give a more realistic finish. Soften the marks with a damp brush, and continue darkening the veins.

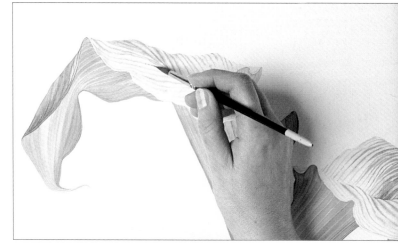

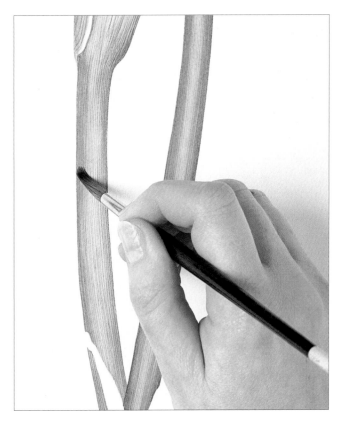

24. *Applying the unifying wash to the stems.*
To strengthen the stems, apply a soft, unifying wash of a dark green mix of indigo, cadmium yellow pale, cadmium red deep and cerulean blue tone. First lay a clear glaze by sweeping a damp No. 6 brush gently along the stem. Then, with the same brush, run the dark green down either side so that the colour blends into the centre, leaving a natural highlight down the middle of the stem.

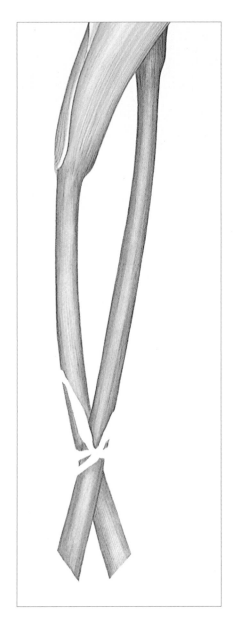

The completed stems

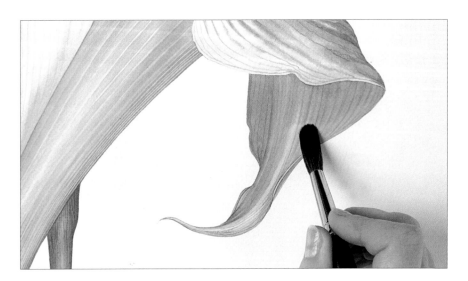

Adding the shadows.
25. Complete the spathes by adding any final, sharp shadows using the appropriate depth of wash. To create shadows, mix the mid-tone colour of French ultramarine, cadmium yellow pale and cadmium red deep in the ratio of two blue to one red to one yellow. Water down the mix and add a hint of the pale green mix. Apply the wash to the shaded parts of the plants using a No. 12 brush for larger areas and a No. 6 for smaller areas. Lay it very gently over the details, and use a clean, damp brush to soften the edges.

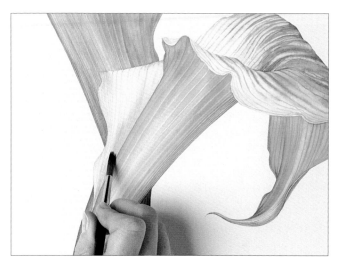

Tip
Keep the mid-tone mix well stirred, or the colours may separate out.

26. Use the same, though more watery, mix for the shadow on the interior of the spathe. Soften the edges of the shadow with a clean, damp brush.

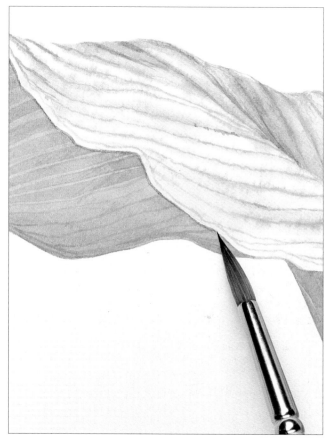

27. Sharpen the edges of the spathes using the tip of a No. 4 brush.

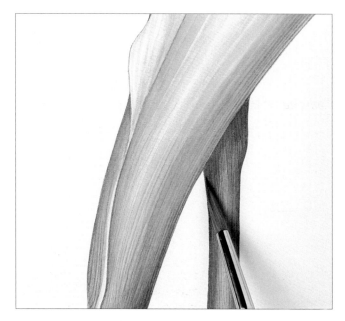

Completing the picture.
28. Complete the flowers by applying a light, mid-green, unifying wash where the colour needs strengthening and softening the green edges with a damp brush. Add the shadow mix used in step 25 to create shadow where the flowers cross over.

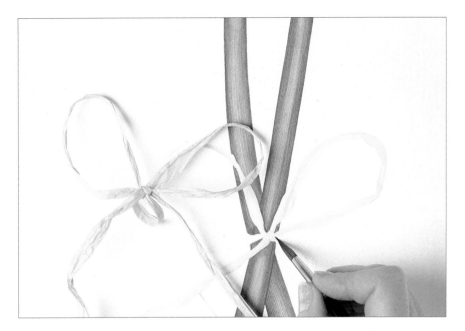

Tip

For artistic purposes, two more ties have been added to the bow in the painting.

The raffia bow.

29. For the raffia, make a mix of permanent rose and cadmium yellow pale. Using a No. 4 brush, map in the raffia using a light wash. For the parts that are in shadow, add a little French ultramarine. As you lay the colour down, lift out any highlights with a clean, damp brush. When the paint is completely dry, rub out the pencil line.

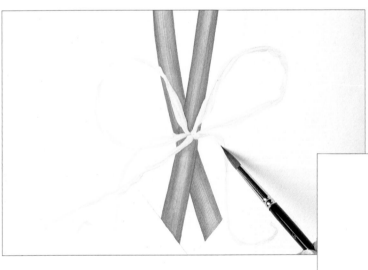

30. Make a stronger mix of the same colours, and use this where the colour intensifies around the knot and in the creases of the raffia.

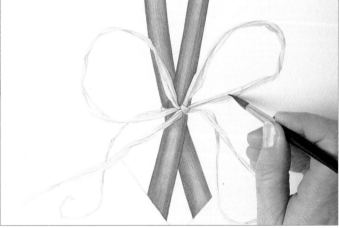

31. Add a little more French ultramarine to the mix to make a more pinky-grey tone, and apply it to the shaded areas and folds, as before.

The completed painting (opposite)

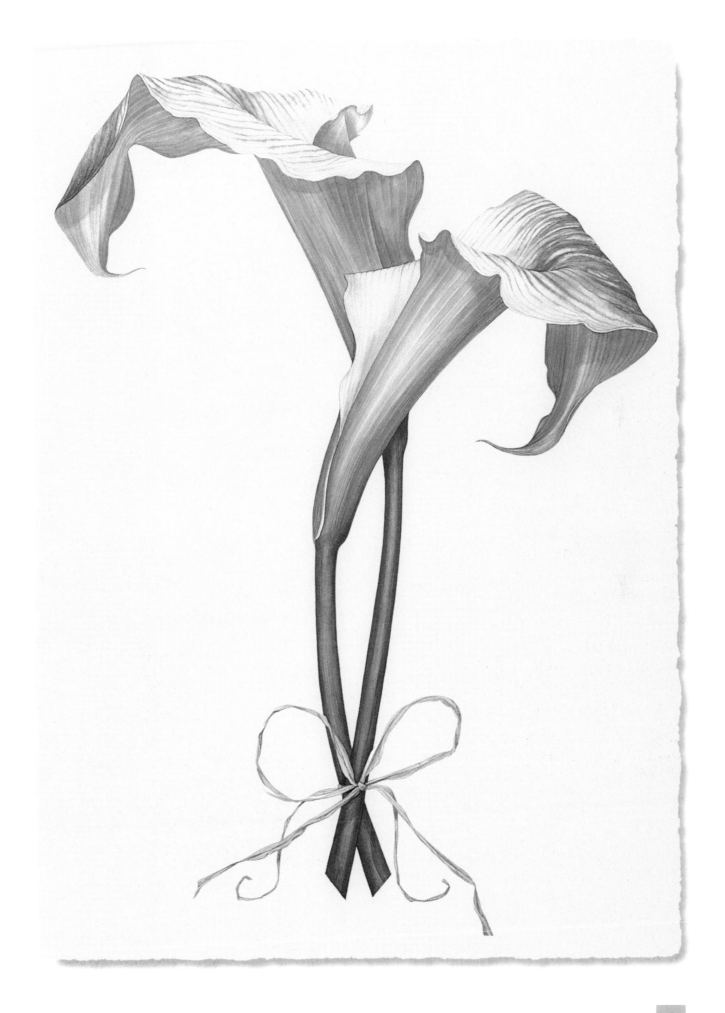

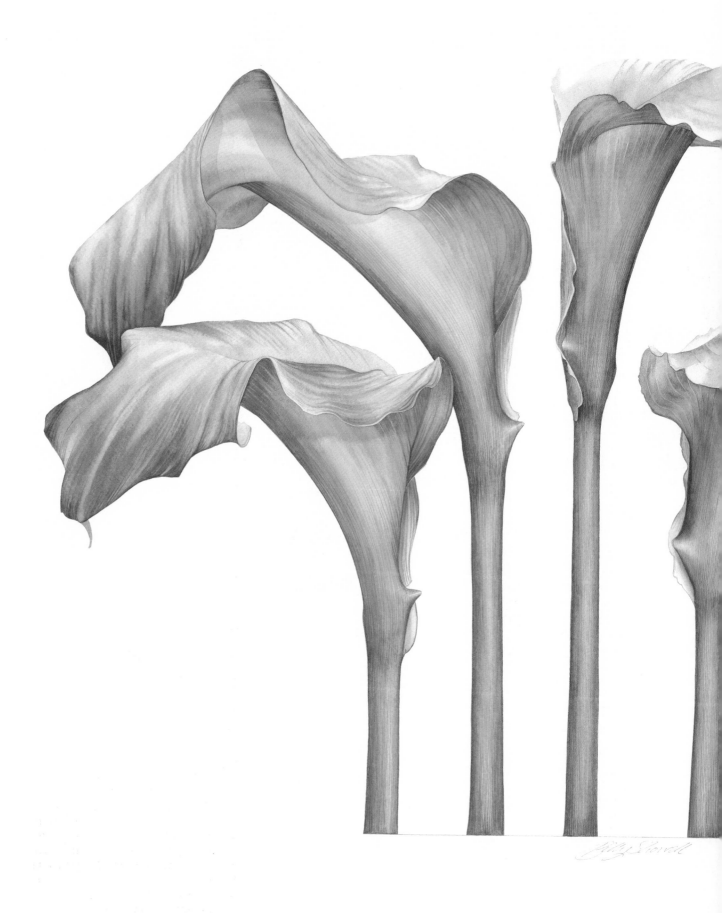

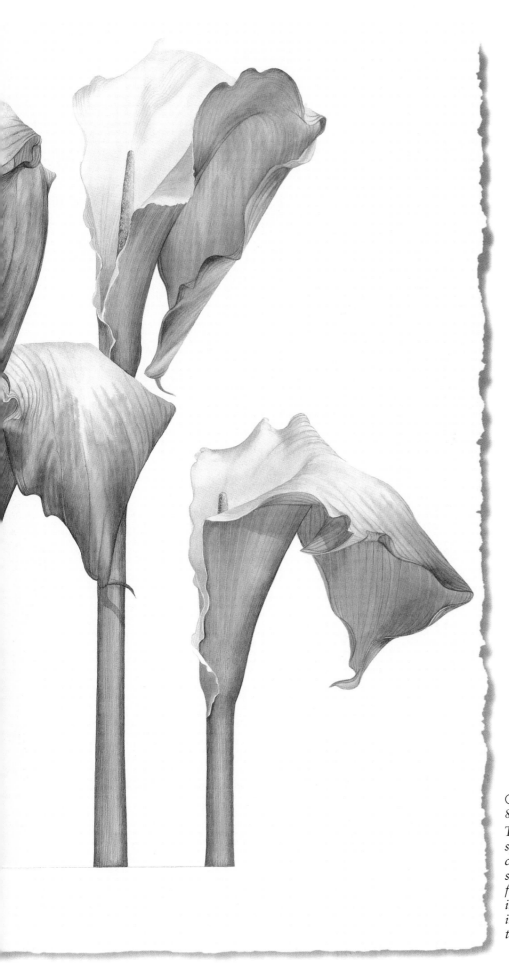

Green Goddess in a Row
80 x 60cm (32 x 24in)

The floppy, curved lips on the spathes of these Green Goddess lilies contrast well with the regimental style of the stems. By showing the flowers at all different angles, I have inadvertently created a composition in which they look as if they are talking with one another.

Roses

I bought this rose at the Hampton Court flower show. I love its simple, old-fashioned appeal. The blooms open quite fast and fade away quickly, so I painted it before I planted it out to avoid the wind blowing the petals away. Remember that the open flowers at the top will tend to die sooner than those near the base as they are the oldest.

Working, as I do, in the studio changes the intensity of shadows and highlights. You can see more detail under a bright, artificial light and I was therefore able to paint the plant at various life stages and to emphasise details and shadows that are less apparent outside, in natural daylight.

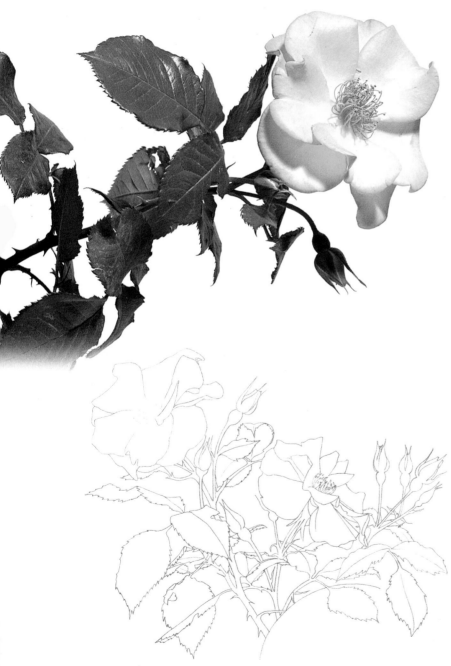

Materials

Sheet of hot-pressed watercolour paper, 60 x 40cm (24 x 16in)

Sharp, HB pencil

Pencil eraser or putty rubber

Pencil sharpener

Roll of absorbent kitchen towel

Sable paintbrushes, No. 4 and No. 6, with extra fine points

Length of raffia tied in a bow

Watercolour paints in alizarin crimson, cadmium lemon, cadmium red deep, cadmium yellow pale, cerulean blue tone, French ultramarine, permanent rose and quinacridone red

Basic mixes

Pink
permanent rose and cadmium yellow pale

Bright green
cadmium yellow pale and cerulean blue tone

Darker green
bright green mix with French ultramarine and a hint of cadmium red deep

Drawing the outline.
1. Draw the composition using a sharp HB pencil.

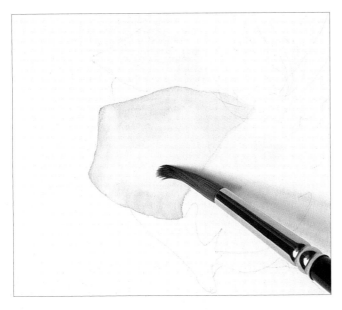

Tip

It is good practice to lean your arm on a sheet of plain paper when you begin painting, to prevent smudging your drawing.

Laying the first washes.

2. Begin by mixing the two basic washes – one of permanent rose and cadmium yellow pale and the other of cadmium lemon. Starting with the left-hand flower, use a No. 6 brush to lay a clear glaze of water to one of the petals, and a small amount of cadmium lemon near the centre of the flower. While the glaze is still wet, drop in the pink. Gently move the paint around. To show the curve of the petal, lift out colour using a slightly damp brush to create highlights.

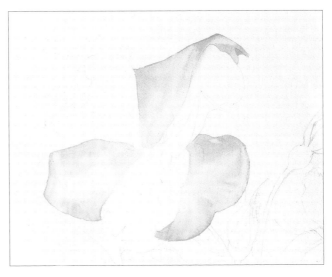

3. Paint alternate petals in the same way. As each petal dries, rub out the pencil lines.

Tip

Work swiftly to lift out highlights, because permanent rose can stain the paper.

Tip

Although I have worked this painting from left to right, if you are left-handed you may prefer to work from right to left.

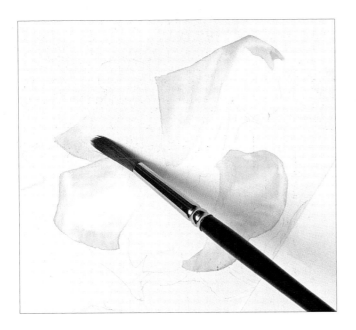

4. Once these are dry, paint the remaining petals. This technique helps prevent wet paint from spreading to adjacent petals and spoiling the gentle washes.

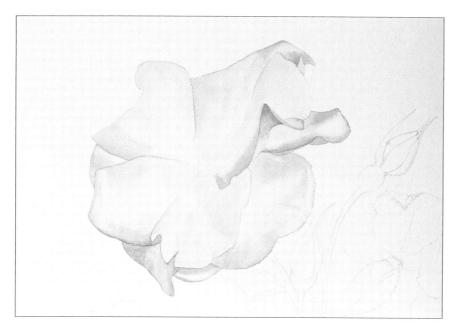

5. Complete all the petals. When you paint the lower petals, add more pink to the mix to strengthen the tone. When you have finished, allow the paint to dry thoroughly.

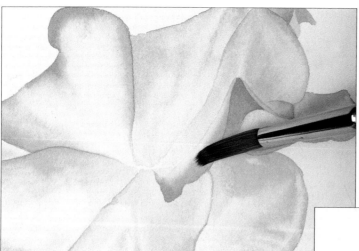

6. Deepen the edges and folds of the petals using a stronger, less watery pink mix, glazing with water the areas you wish to paint first.

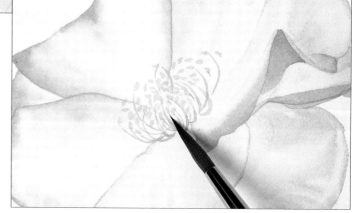

Painting the stamens.
7. Start painting in the stamens. Use a mix of cadmium yellow pale, a little cadmium red deep and French ultramarine to make the yellow for the anthers (the tips of the stamens). Map these in first, using a watery mix and a No. 4 brush. For the filaments (the stems of the stamens) use a mix of cadmium lemon and permanent rose. Paint them on using just the tip of the brush.

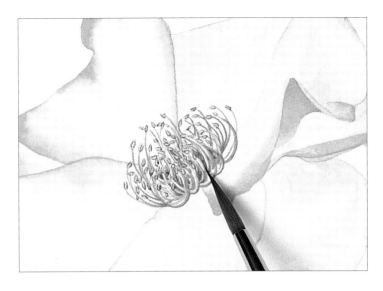

8. Make a darker mix of French ultramarine, permanent rose and cadmium yellow pale for adding detail to the underside of each stamen. Darken the very centre of the stamen clump with a small amount of alizarin crimson.

9. Define each anther by adding a small amount of shadow. Use a mix of French ultramarine, cadmium yellow pale and cadmium red deep.

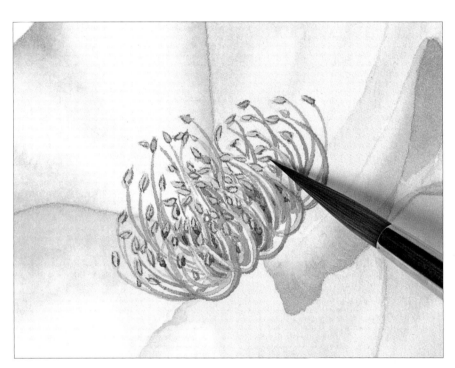

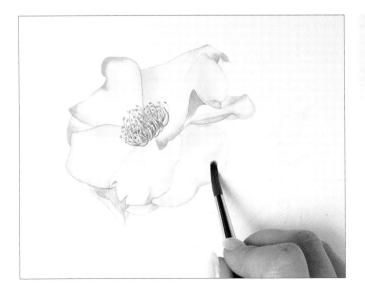

Tip
The pinks may fade as they dry, so strengthen them up as you work.

Applying shadows.
10. Apply shadows using a watery mid-tone mix of French ultramarine, cadmium yellow pale and cadmium red deep (see page 35). First use a No. 4 brush to glaze the area where the shadow lies, then apply the mid-tone. Soften the edges with a clean, damp, No. 6 brush.

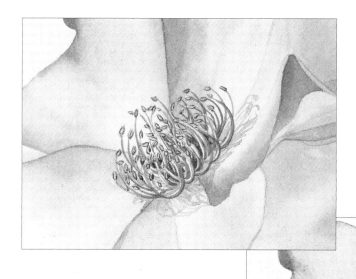

11. Paint the shadows of the stamens using the same mid-tone mix and the tip of a No. 4 brush. Paint them on to dry paper.

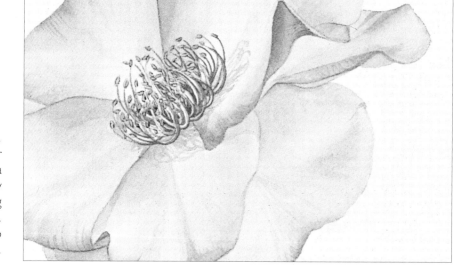

Adding the surface veining.
12. For the delicate surface veins, water down the mid-tone as in step 10 and add a little permanent rose to make a pale, watery mix. Paint on the veins very lightly using gentle sweeps with the tip of a No. 4 brush. Add small areas of a darker mix of pink to the petal folds and creases.

Tip

It is up to you how many buds and leaves you work on at a time. For example, you may wish to complete all of the buds before moving on to the leaves, or alternatively you may prefer to paint all the buds and leaves on one side of the painting first and then work your way across to the other side.

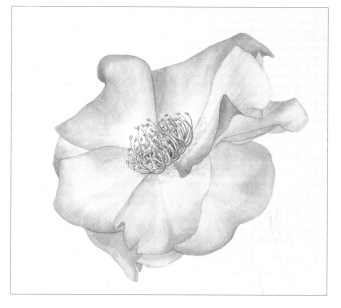

13. Strengthen up the pink by laying a pale pink wash over the petals using the basic pink mix. Lift out the highlights with a clean, damp brush.

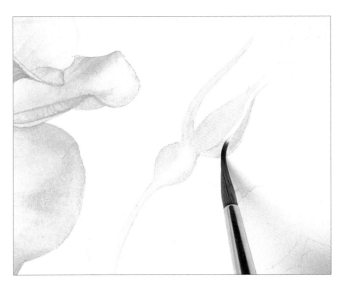

Painting the buds.

14. For the buds, you will need to make the two basic green mixes, and a small puddle of alizarin crimson. Using a No. 4 brush, begin by adding a clear glaze to each sepal at the base of the bud, then drop in the bright green. Lift out highlights with a clean, damp brush.

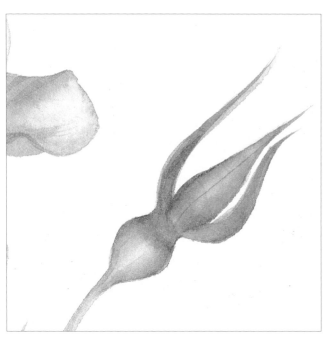

15. Define the form of the bud with the darker green mix. Glaze it with water, and then drop in the green and add a touch of alizarin crimson to the stem before it dries.

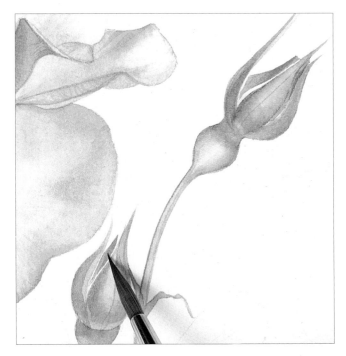

16. Complete the green parts of all the buds on the left-hand side of the painting, then mix a little quinacridone red with permanent rose for the inner petals. Because these areas are so small, paint on to dry paper and use a No. 4 brush. First map in the inner parts of the bud, then while the paint is still wet strengthen the darker areas using the same mix with a little alizarin crimson added to it. Leave a thin white border around the edges of the sepals. Repeat for the remainder of the buds.

Tip

When adding darker washes, work around the highlights and soften into them with a clean, damp brush.

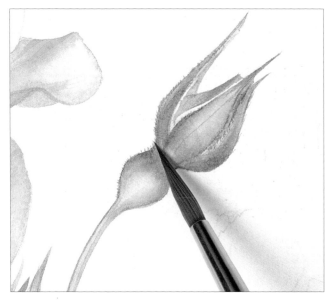

17. Using the tip of the No. 4 brush, add in the fine details (hairs and surface texture) using the dark green mix. To each sepal add a small spot of pink to the tip and a thin green line down the centre.

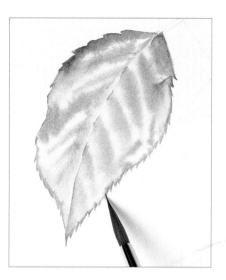

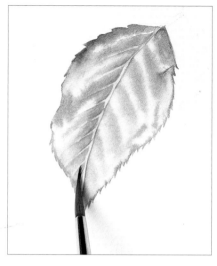

Painting the main leaves.

18. Begin by laying a clear water glaze over a single leaf using a No. 6 brush. Drop the darker green mix around the highlights. Lift out any highlights that are lost with a clean, damp brush.

19. Continue laying the first glaze, then while the glaze is still wet define the serrated edge of the leaf using the same green mix and the tip of a No. 4 brush.

20. Put in the midrib using the bright green mix. When that is dry mark out the sections between the veins, and soften them in to the leaf using a clean, damp brush.

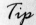

Tip

When painting leaves with a strong midrib, work one half and then the other.

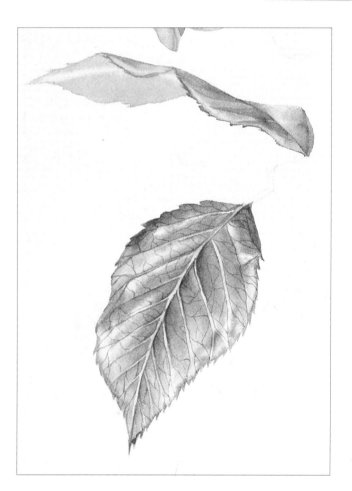

21. When the leaf is dry, add a touch of French ultramarine to the bright green mix and paint in the fine veins using the tip of the No. 4 brush.

22. When the veins are complete, glaze over the leaf with a unifying wash of the darker green mix to darken the tone between the veins. Take care to preserve the highlights. Paint all the leaves in the top left-hand part of the picture in the same way and allow them to dry.

Meanwhile, map in the undersides of the leaves using the basic bright green mix with a small touch of cadmium red deep added to it. Leave these to dry while you continue with the upper leaf surfaces.

Completing the upper leaf surfaces.

23. Return to the first leaf, add a little more cerulean blue tone to the bright green mix and lay a glaze over the whole leaf, avoiding any highlights. Blend in around the highlights with a clean, damp brush. Apply the dark green mix in the same way once the first glaze is dry.

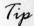

Tip

Use the brush very lightly so as not to overwork the paper or lose any detail.

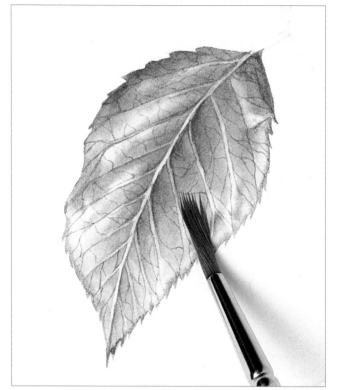

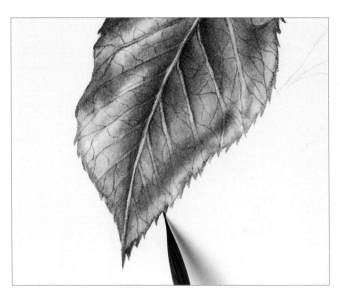

24. Allow the paint to dry, then add touches of alizarin crimson to the leaf stem and the tips of the serrations along the edge of the leaf. Soften the paint in to the leaf with a clean, damp No. 6 brush.

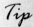

Tip

As the paint dries, remove any unwanted pencil marks.

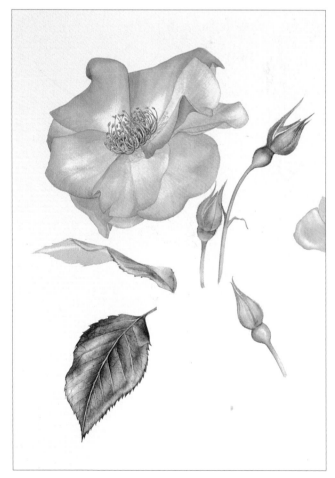

25. Look carefully over the completed leaf and strengthen up the veins and any other areas where necessary. Complete the remaining leaves in the same way.

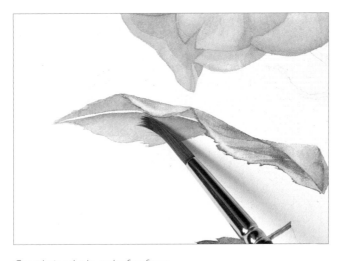

Completing the lower leaf surfaces.
26. Working now on the undersides of the leaves, strengthen these up using the bright green mix. Darken along each side of the midrib.

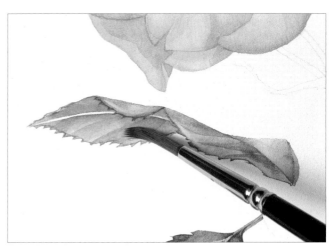

27. Darken the mix with a little French ultramarine, and add in the surface details.

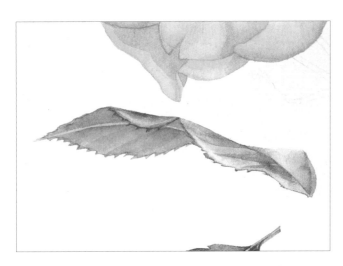

28. When dry, add more cadmium yellow pale to the mix and lay a unifying wash over the whole of the lower leaf surface, including the midrib.

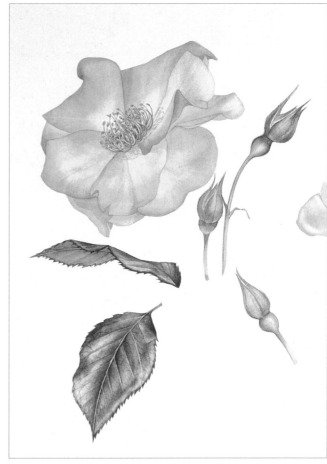

29. Strengthen up the serrated edges with the darker green mix and add a little alizarin crimson to the tips as before.

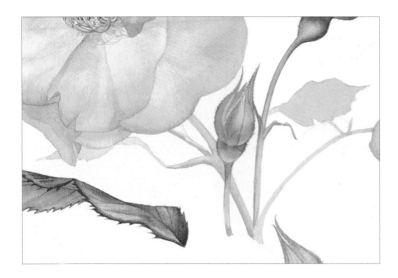

Painting the stems and small leaves.

30. Map in the stems and small leaves in the top left-hand part of the painting using the bright green mix. While the paint is still wet, add shadows to the stem by dropping in an olive green mix of cadmium lemon, French ultramarine and a little cadmium red deep.

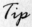

Tip

With overlapping leaves, wait until one leaf has dried completely before painting the other, and always paint the less detailed of the two first.

31. Continue mapping in the small leaves, then when dry remove all the pencil lines. Add the pink areas to the stems using the basic pink mix applied to dry paper with the tip of a No. 4 brush.

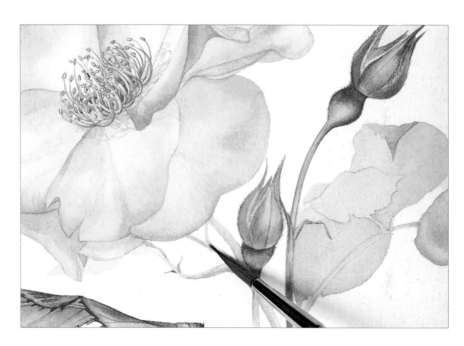

32. Glaze the stem and use the olive green mix (see step 30) to add more shadow to either side, depending on the direction of the light. When dry, add a little more cerulean blue tone to the mix to make a blue-green, and apply this to the other side of the stem. When the paint is dry, remove any unwanted pencil marks.

Painting on the thorns.
33. Lay a clear glaze of water over the remainder of the stems, then apply the bright green mix. While the stem is still damp, apply the olive green mix (step 30) to one side to create shadow. When it is dry remove any unwanted pencil marks. Paint on the thorns using the basic pink mix. Use the same mix for the touches of pink on the stems.

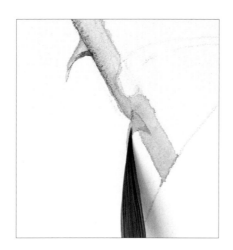

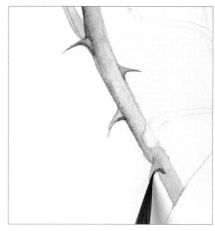

34. For the shadows on the underside of the thorns, mix a little green in with the pink.

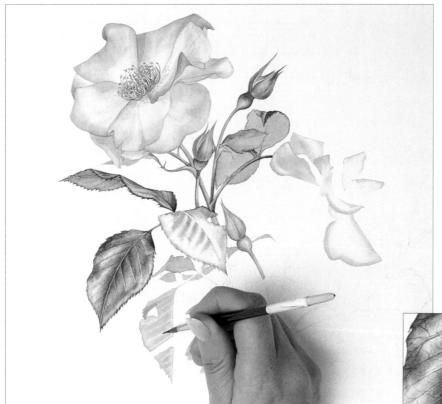

35. Continue mapping in the remaining leaves, working towards the bottom of the painting. On the undersides, lift out the veins with the point of a clean, damp No. 4 brush.

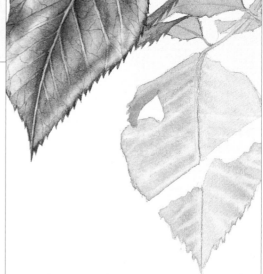

36. Continue to build up the layers of green on the leaves to achieve the right tone.

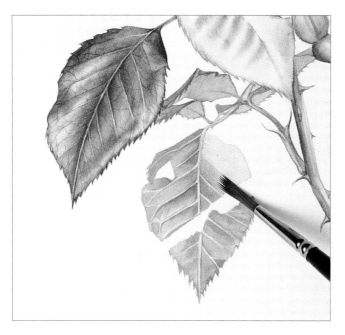

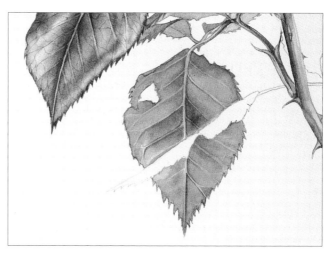

38. Outline the serrated edges of the leaves using alizarin crimson, then add a unifying wash of cadmium lemon, cerulean blue tone and a little cadmium red deep to the whole leaf. Slim down the veins if they are too wide by painting up close to them using a slightly darker green.

37. Add a little French ultramarine to the bright green mix, and lay small areas of glaze in-between the veins. Soften them into the leaf using a No. 6 brush.

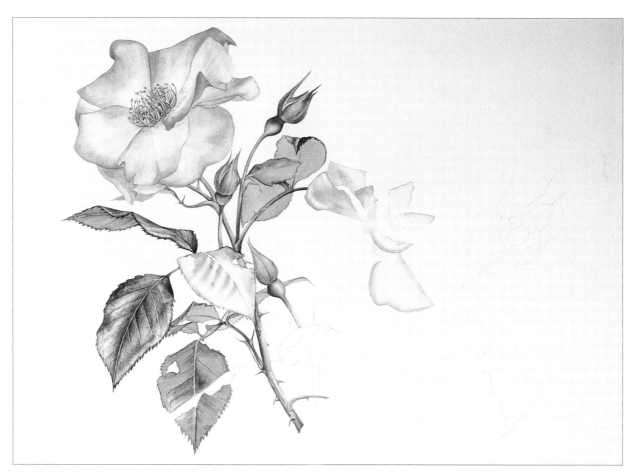

39. Continue painting the plant, working from left to right and from top to bottom. Complete the right-hand side of the painting following the same procedure as the left, finishing the main flower first, then the buds, leaves and stems as you progress downwards.

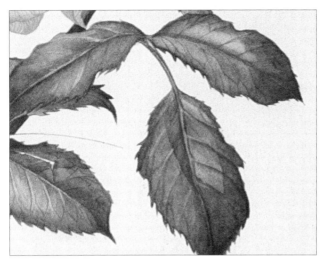

The finished
painting. The curved
pencil line forms
part of the design
and also frames
the signature.

Three Roses
40 x 50cm (16 x 20in)
This painting brings out the proud nature of these straight-stemmed blooms.
They look almost as if they are trying to outgrow each other.

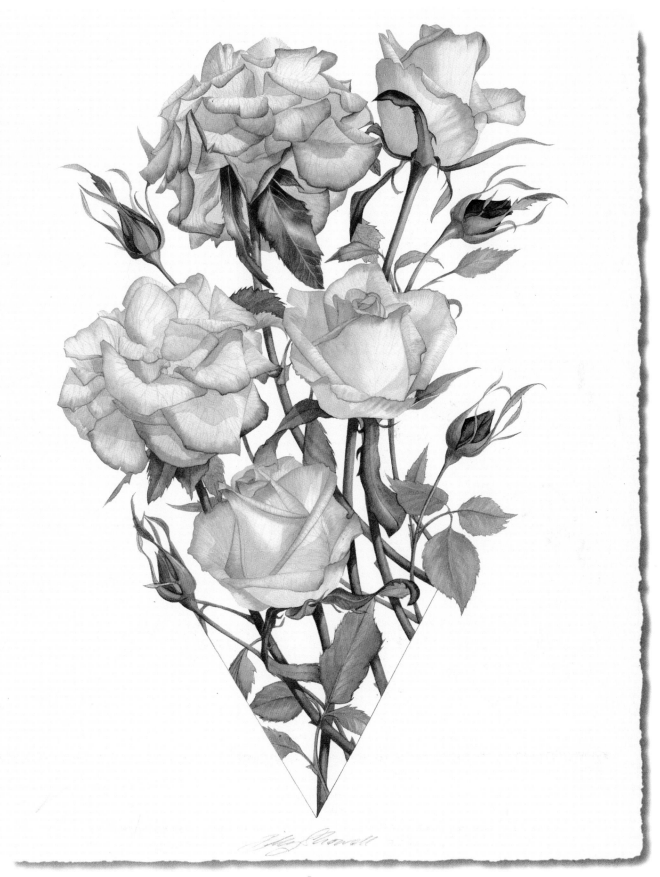

Roses
40 x 50cm (16 x 20in)
The intention of this composition was to highlight the rambling nature of the roses, which are seen here pushing their way forwards, emerging triumphantly on the page.

Delphinium

The delicate nature of the delphinium and the jewel-like quality of its blue flowers make it a wonderful subject for a watercolour painting. I love tall blooms, and this flower positively called to me to paint it! The flowers last a long time when cut, but it is still advisable to paint the them quickly as they are very delicate. Delphinium blooms are usually available to buy in the late summer. Support the flower while you are painting it in wet oasis, or anchor it to the side of a medium-size vase with the water as high as possible.

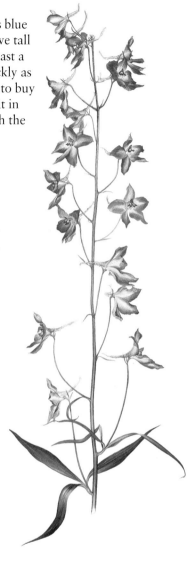

Materials

Sheet of hot-pressed watercolour paper, 30 x 75cm (12 x 30in)

Sharp, HB pencil

Pencil eraser or putty rubber

Pencil sharpener

Roll of absorbent kitchen towel

No. 4 round sable brush with an extra fine point

Watercolour paints in cadmium lemon, cadmium red deep, cadmium yellow pale, cerulean blue tone, cobalt blue, French ultramarine, mauve and quinacridone magenta

Basic mixes

Dark blue
French ultramarine and quinacridone magenta

Light blue
cobalt blue

Bright green
cadmium yellow pale and cerulean blue tone

Dark green
French ultramarine, cadmium yellow pale, cerulean blue tone and a touch of cadmium red deep

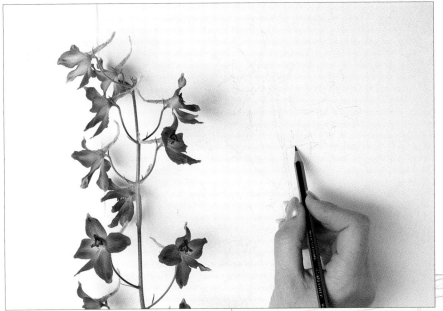

Sketching the outline.
1. Begin by sketching out your plant. Because the flowers are very delicate, they may change during the time you are painting, so keep your drawing as loose as possible.

Laying the first wash.
2. Begin by making two puddles of the basic blue mixes. Because the plant is very long and narrow, you may find it easier to turn your painting sideways and work from top left to bottom right. That way you do not have to lean forwards over your work to paint the top part of the plant.

Lay a clear water glaze on one petal of the first flower you wish to paint, then drop the dark blue mix into the centre of the petal and the light blue around the edge.

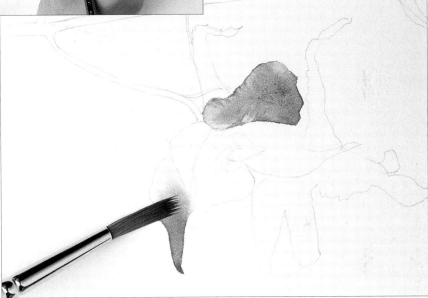

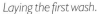

Tip

Keep the dark blue mix well stirred to prevent the colours from separating out.

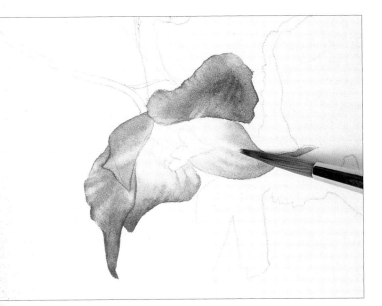

3. Before the paint dries, lift out any reflections or highlights using a clean, damp brush. Continue painting alternate petals, then when these are dry paint the ones in-between. Paint four or five more flowers in the same way, moving down towards the bottom of the picture.

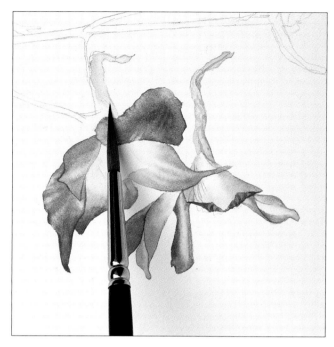

Painting the spurs.

4. For the spurs, use two watery mixes – a dull, pale green mix of cadmium yellow pale and a hint of cobalt blue, and mauve. First glaze the area with water, then drop in the two mixes, allowing them to blend freely. Lift out any highlights as the paint is drying, and drop in lighter and darker dabs of colour to create texture before it dries completely.

Move from flower to flower, varying the blues to match the tone of the flowers – some will need more of the dark blue mix whilst others will require more of the light blue. Rub out the pencil lines when the first wash is dry.

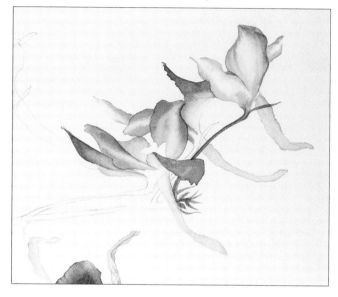

Painting the thin stems.

5. As you progress across the painting, start to paint the thin stems that join the flowers to the main stem. Use the bright green mix with a little cadmium red deep added to it. For the shadows along the edges of the stems, add a little French ultramarine to the mix to darken the wash.

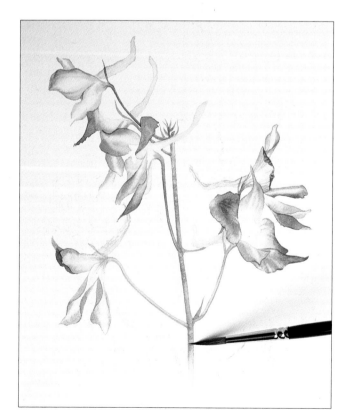

Painting the main stem.

6. Paint the main stem in the same way as the thin stems. When the first greens are dry, lay another clear water glaze down the stem and drop in spots of the darker green to create the markings. Continue to build up the colour on the stems by adding darker green shadows.

Adding the details.

7. Using a bright green mix, paint on the green spot on the underside of each petal, near the tip. Soften the edges with a damp brush, and pull some of the green back into the petal as you do this.

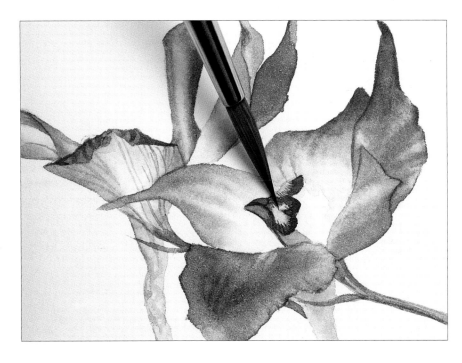

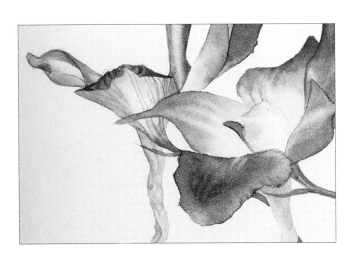

8. For the centres of the flowers, first add a yellow blush using cadmium yellow pale. This will become the basis for the yellow hairs in the centre of each flower. Apply the paint in the same way as the green spots – first put down a little paint, and then soften the edges.

9. Use mauve to paint in the central part of the flowers around the yellow blush. Use small, feathery brush strokes with the very tip of the brush, painting from the yellow outwards, to create the hairs.

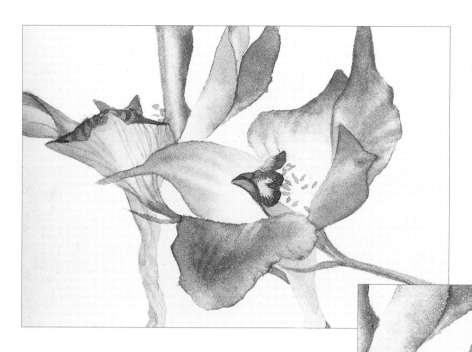

10. Add a little more cadmium red deep to the bright green mix to make a dull green, and spot in the anthers.

11. Make a watery, pale, lilac-grey mix using mauve and a little of the dull green mix, and define the stamen filaments (the stems of the stamens) using fine strokes of the tip of the brush.

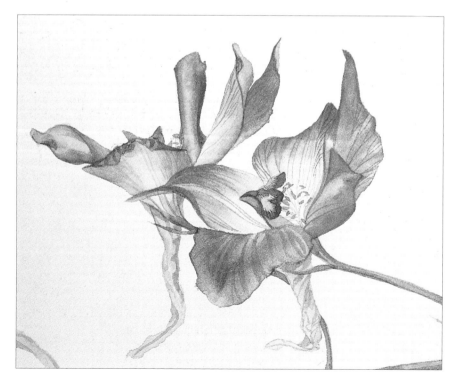

12. Build up the surface detail on the petals using cobalt blue. Paint on the veins and soften them with a damp brush where necessary. These veins are very fine, so use the tip of the brush and apply each one in a single sweep.

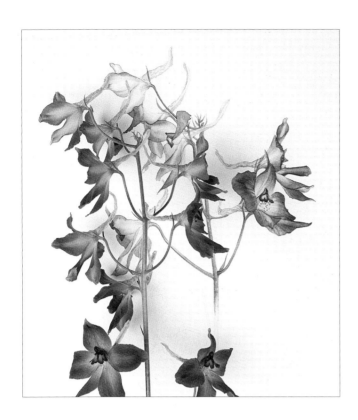

Strengthening the colours.

13. When dry, strengthen up the colours of each flower by applying a clear water glaze and a combination of the dark blue mix and cobalt blue (see step 2).

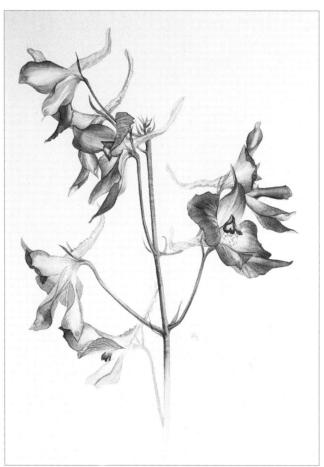

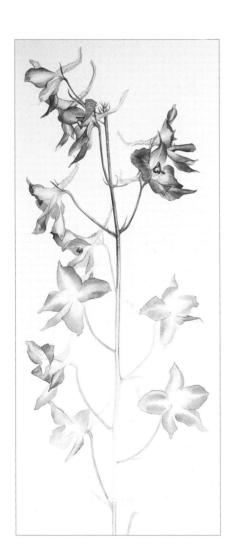

14. Build up the detail on the backs of the petals – the veins and folds – with a pale wash of mauve, and strengthen the colour as in step 13. Add shadows to the stems using the basic shadow mix (see page 34).

15. Continue painting the remainder of the plant in the same way, gradually working your way down towards the base.

121

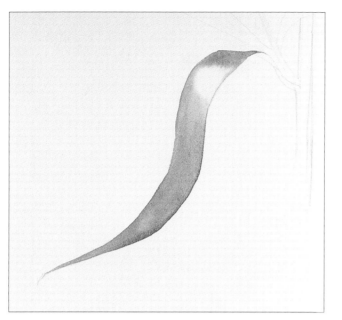

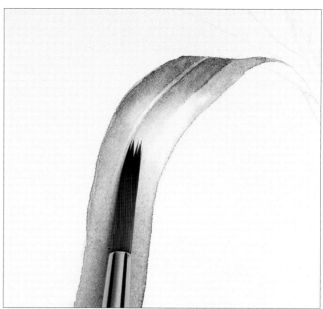

Painting the leaves.

16. Make up the basic dark green mix. Apply a clear water glaze to the first leaf you wish to paint, then while it is still wet lay on the green mix, leaving a clear area with soft edges for the highlight.

17. Brighten the mix by adding some cadmium lemon and cerulean blue tone to add a little more colour to the leaf. When laying on this colour leave little spaces for the veins. Using a clean, damp brush, pull a little colour down into the highlight.

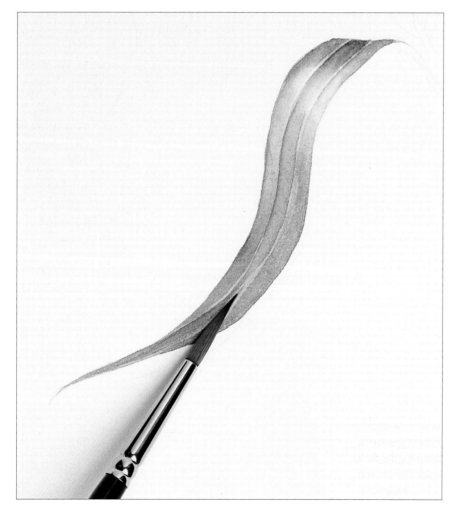

Tip

Start the lower leaves before completing the top part of the plant as these are likely to wilt first.

18. Continue building up the colour along the leaf with the same bright green mix you used in step 17. Paint in the spaces either side of the veins. When the paint is dry, build up the green tones with more layers, darkening the leaf towards the tip and the base.

Tip

Study the veins on the leaf carefully and paint what you see, not what you think you should see.

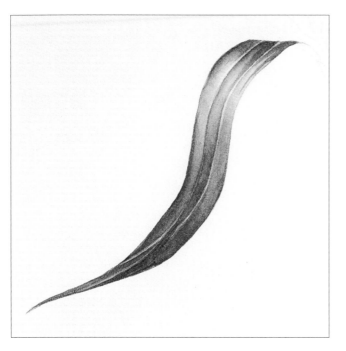

19. Add a little shadow down the sides of the veins using the dark green mix. Use the same dark green to strengthen the sides of the leaf.

20. When the leaf is dry, make a watery mix of the basic bright green and glaze over the whole leaf, dragging a small amount over the highlight.

21. Complete the remaining leaves in the same way.

22. Paint the thin stems that join the leaves and flowers to the main stem using the bright green mix used in step 17, and darken the sides using the dark green mix. Start by glazing with clear water then drop in the greens.

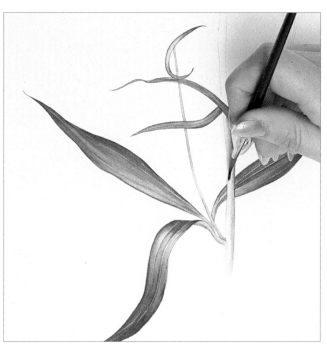

23. For the underneath of the leaves, use a paler, less vibrant green than the one used on the upper surfaces. For this, make a watery mix of cadmium yellow pale and French ultramarine.

24. For the main stem, mix up a bright, strong green of cerulean blue tone, cadmium yellow pale and French ultramarine. Glaze the stem with clear water first, dragging the glaze down the stem, and then apply more colour on the side that is away from the light.

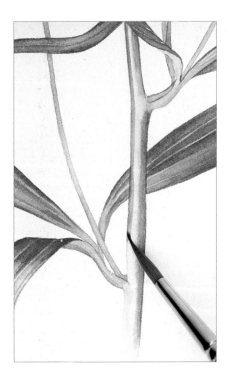

25. When the paint is dry, apply the same mix in a fine line along the edge nearest the light. Soften it on the highlight side, leaving a bright centre to the stem. As each glaze dries, lay on another glaze until you have achieved the desired tone, making sure you retain the highlight by lifting out any straying paint.

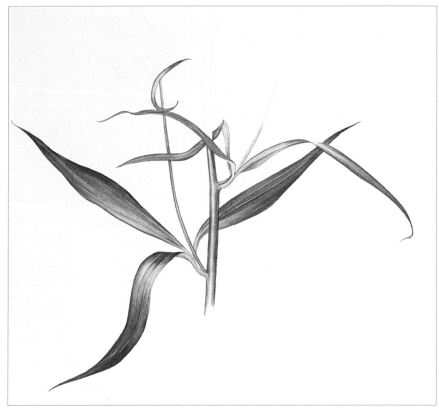

26. Continue painting the remainder of the plant in the same way.

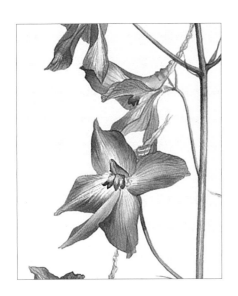

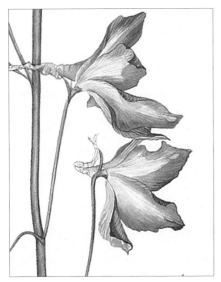

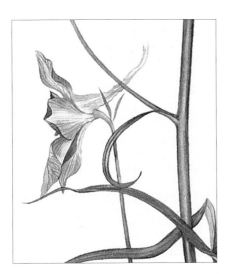

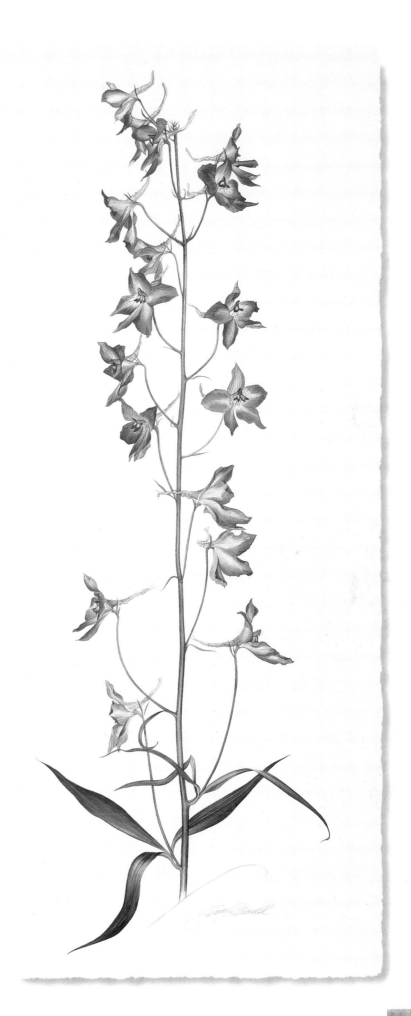

The completed painting

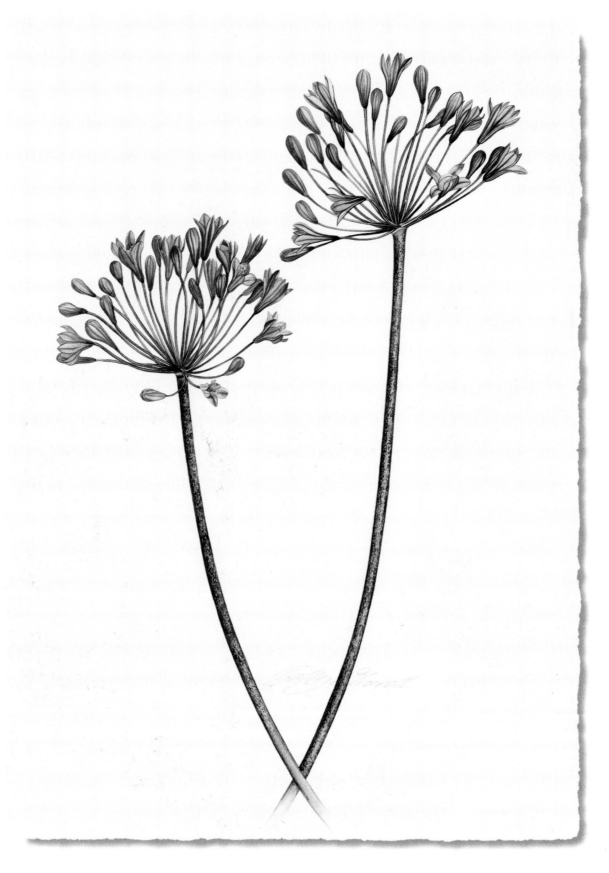

Agapanthus
40 x 50cm (16 x 20in)

Agapanthus have the most wonderful, curving stems. The flower head is complicated but well worth painting. Start with the forward-facing flowers and work towards the back.

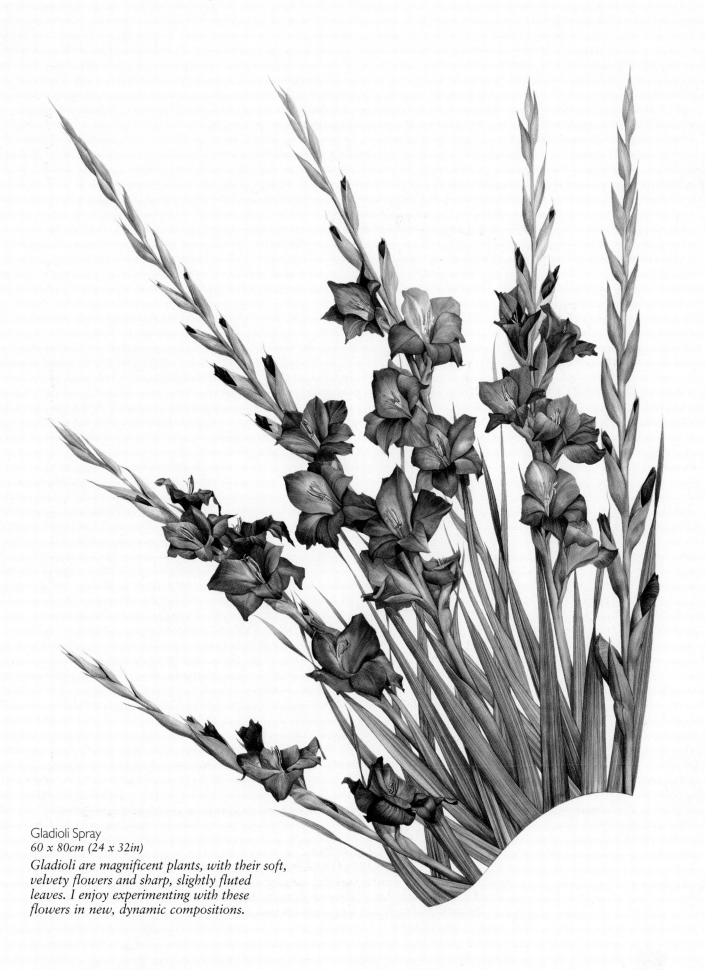

Gladioli Spray
60 x 80cm (24 x 32in)

*Gladioli are magnificent plants, with their soft,
velvety flowers and sharp, slightly fluted
leaves. I enjoy experimenting with these
flowers in new, dynamic compositions.*

Index